MANGA WORLD COLORING

SCOTT HARRIS

COLOR YOUR WAY THROUGH COOL ORIGINAL MANGA ART!

Walter Foster

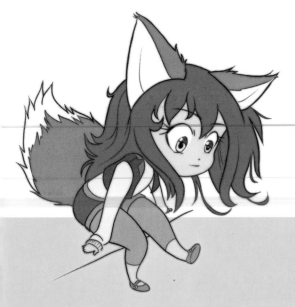

LOVE MANGA? *Manga World Coloring* offers a stress-free escape into the creative world of coloring. Manga lovers of all ages will enjoy using colored pencils, markers, and crayons to color a selection of manga characters and scenes from artist Scott Harris, including fairies, ninjas, schoolgirls, witches, samurai, wizards, chibis, and more!

ABOUT THE ARTIST

Scott Harris is an illustrator, painter, and art instructor. He has taught hundreds of thousands of students to grow their art skills with his courses on ArtSchoolofImagination.com. Whether you're drawing characters or creatures, making manga or comics, painting portraits, or creating video game art, Scott teaches the core art knowledge you need to know. With years invested in learning and teaching art fundamentals, Scott has been able to structure art education in an efficient, easy-to-learn way. A passionate artist and zealous teacher, he strives to bring students to a high level efficiently, with simple, easy-to-understand concepts.

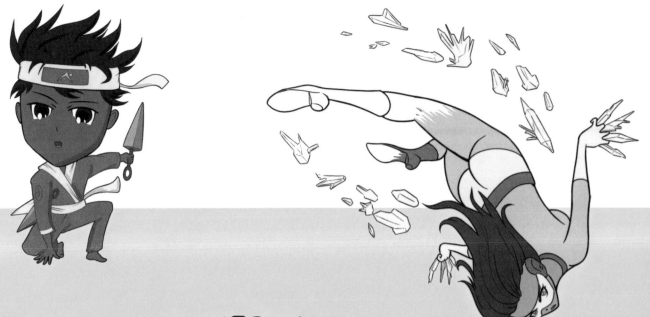

TOOLS & MATERIALS

COLORED PENCILS: Keep colored pencils sharp to create fine lines and broad strokes. They give you a good amount of control over your strokes; the harder you press, the darker the line. You can also use an eraser to tidy up your lines.

CRAYONS: Crayons are a playful, inexpensive way to color your drawings. These wax-based tools have a soft feel and provide quick, textured coverage.

MARKERS: Bold, crisp, and rich in color, markers generally come in three types of tips: chiseled (wide and firm), fine (small and firm), and brush (soft and tapered).

ADDITIONAL MATERIALS: Try using ink pens, gel pens, paint pens, and more to create different coloring effects. Experiment to find your favorite coloring tools. The sky is the limit!

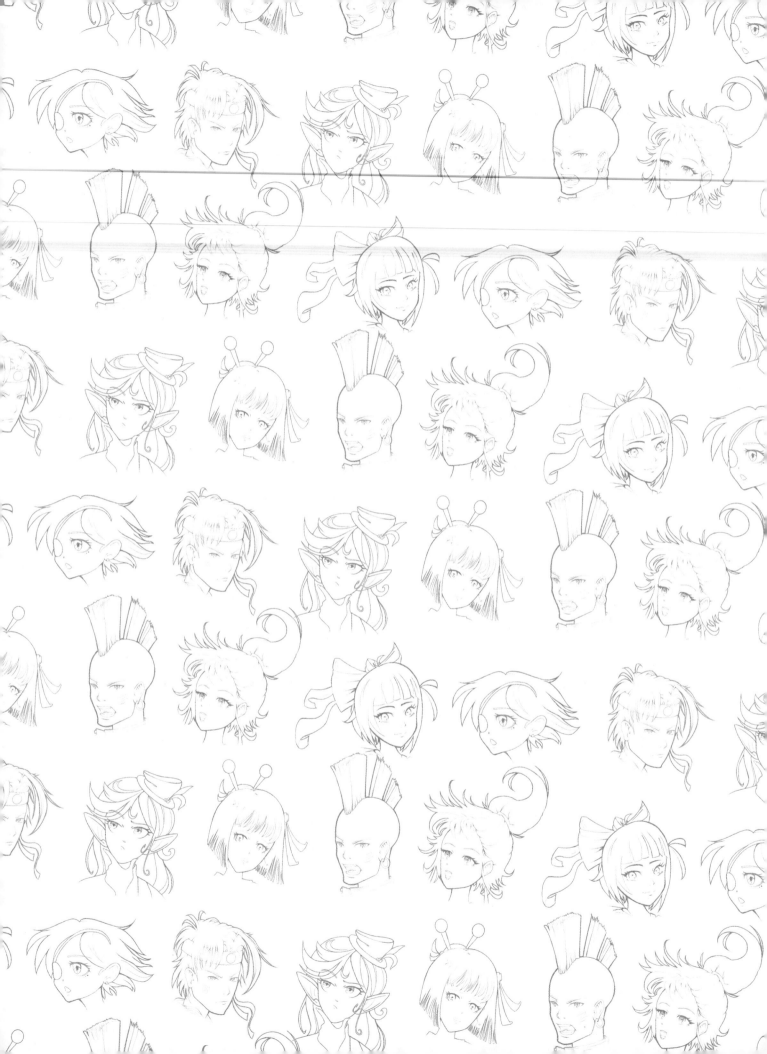

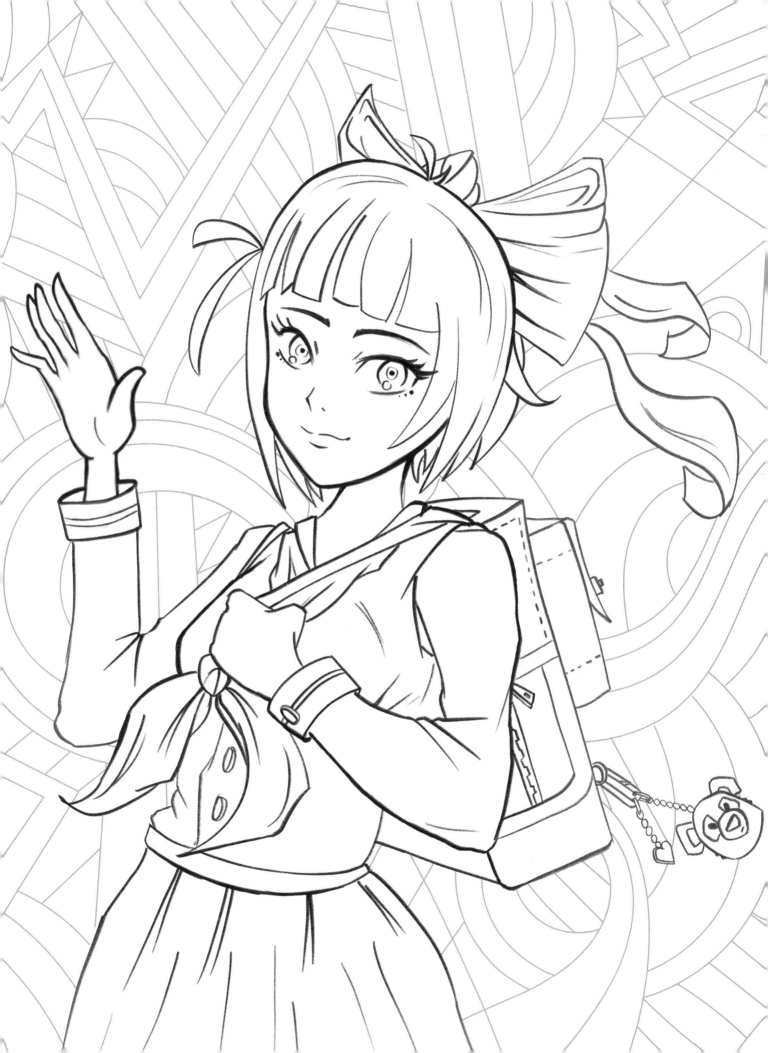

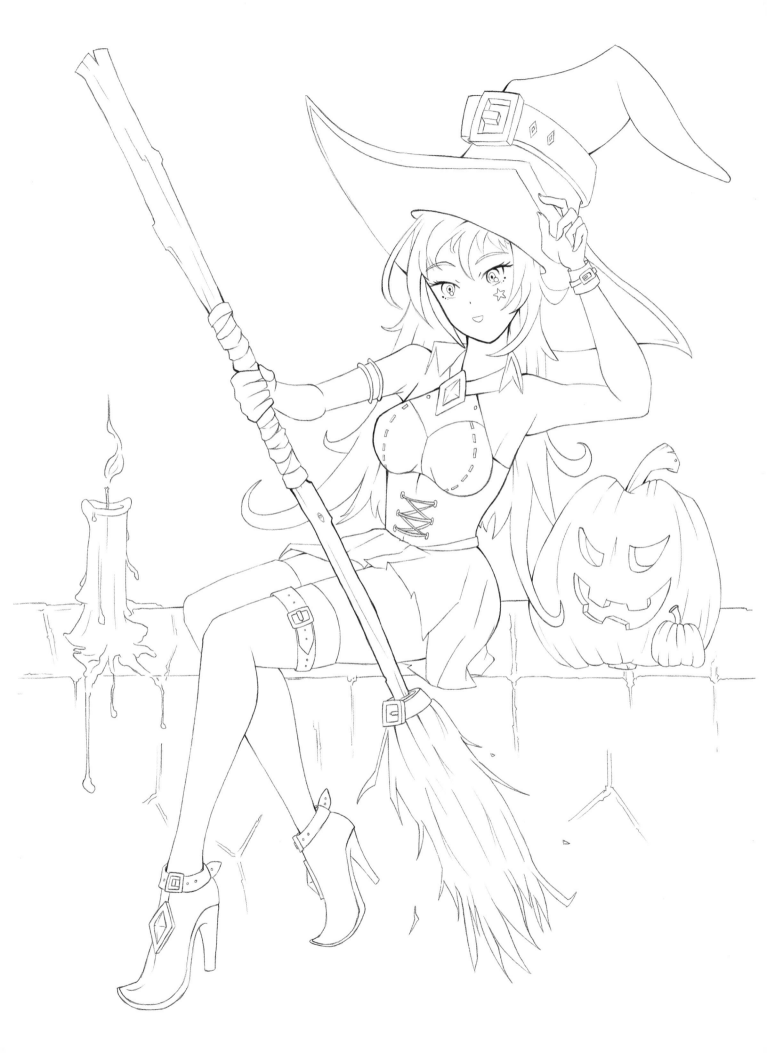

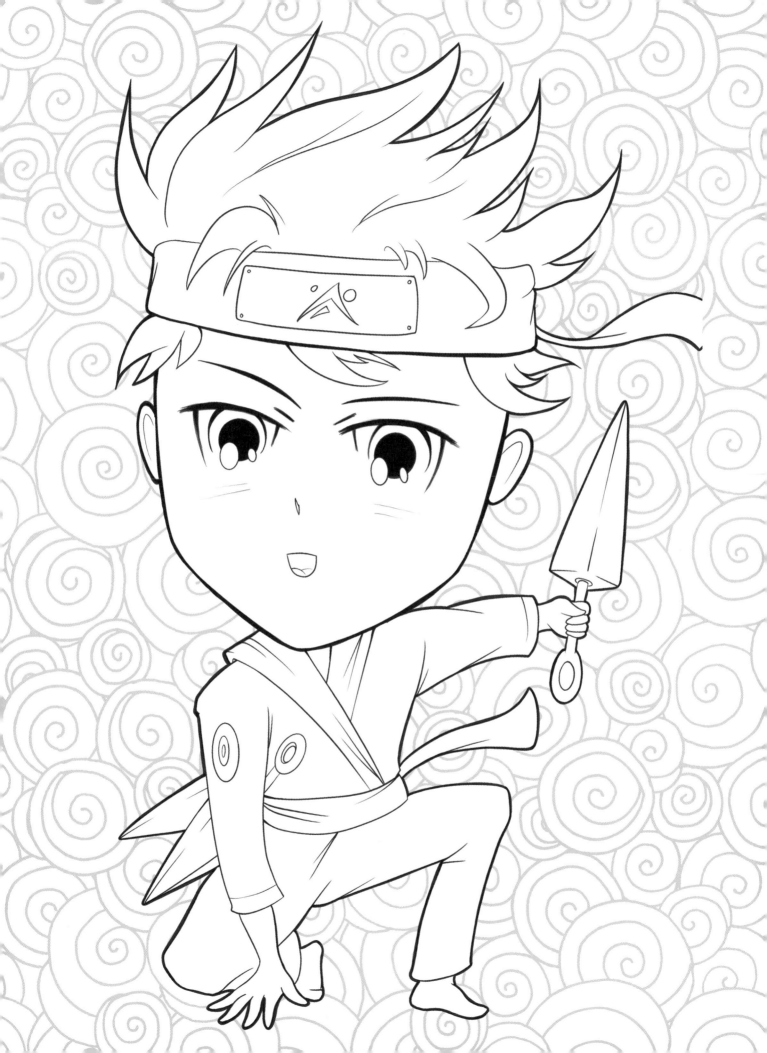

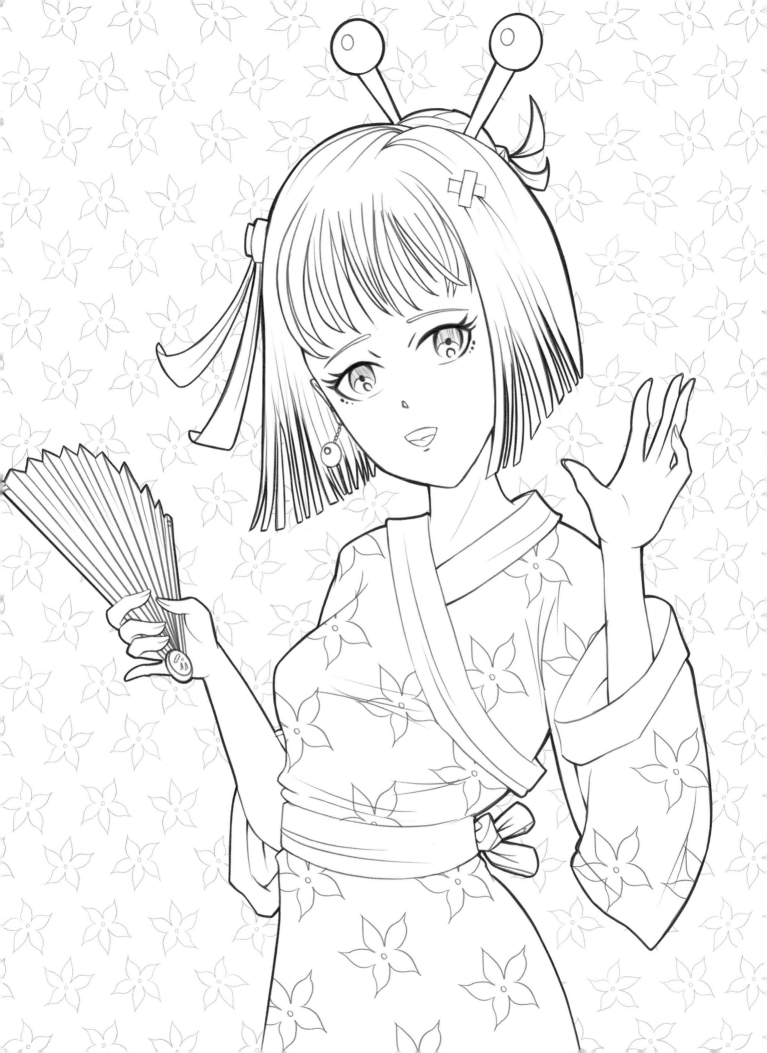

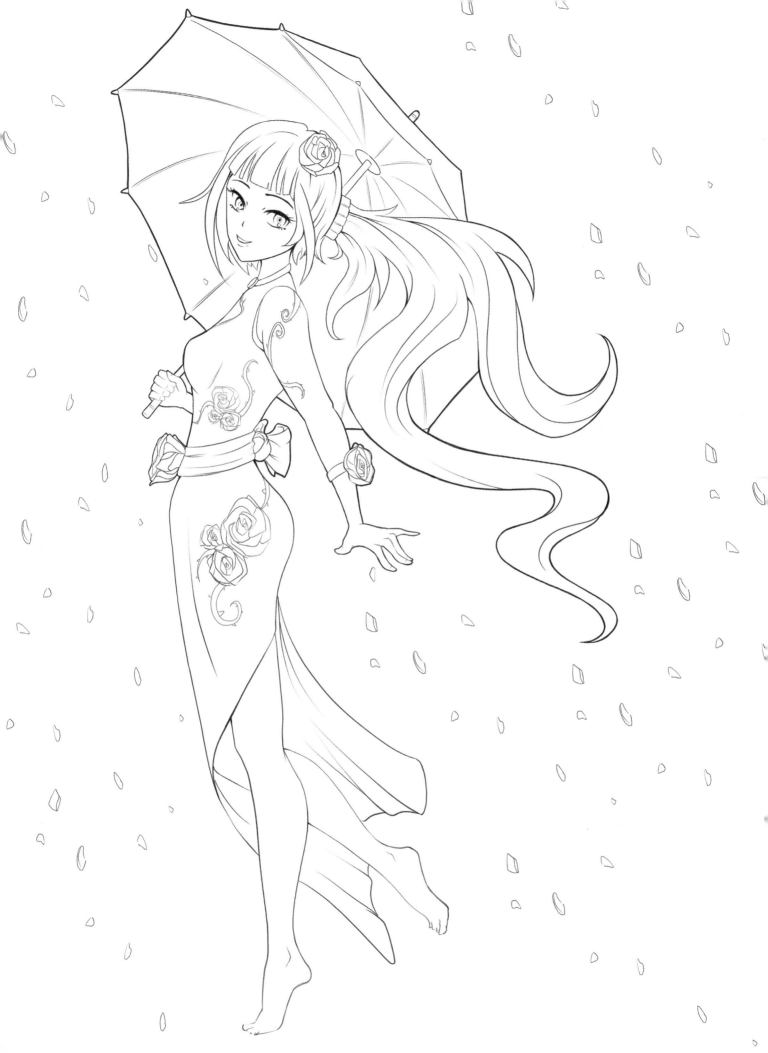

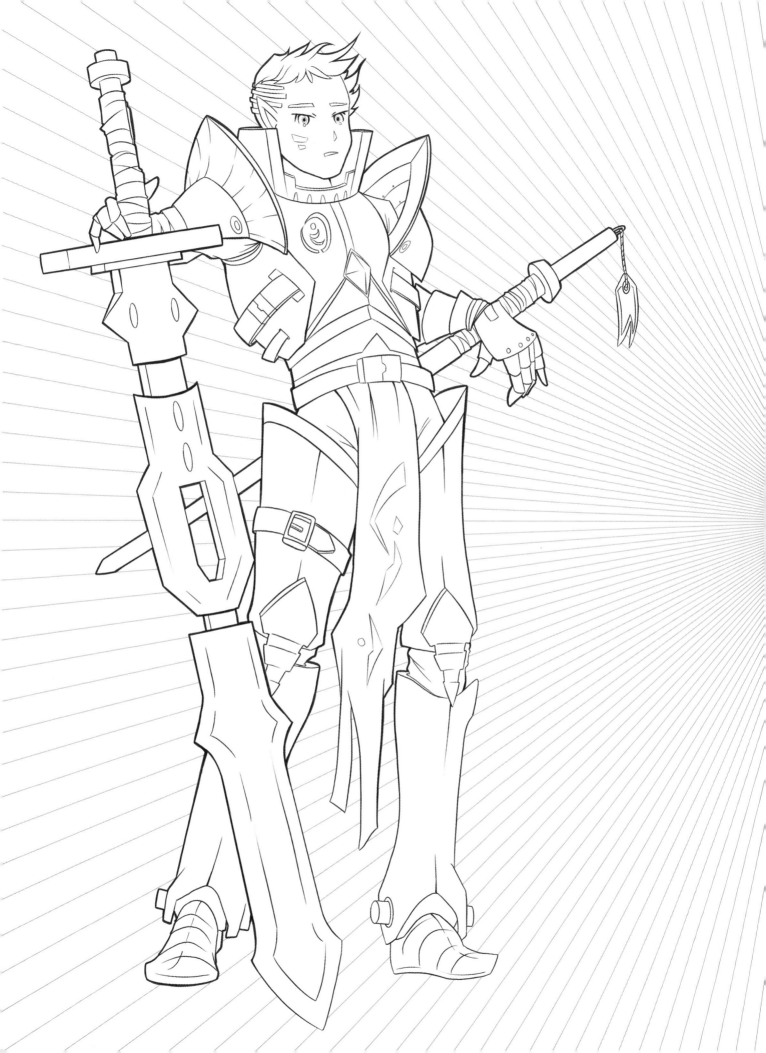

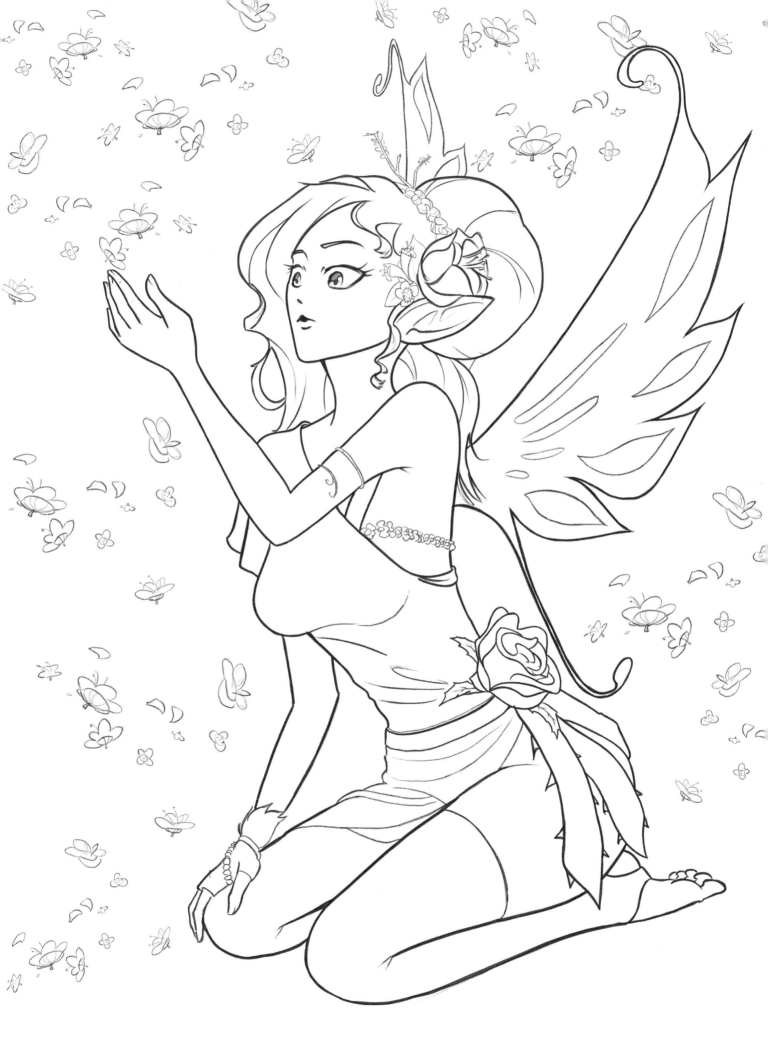

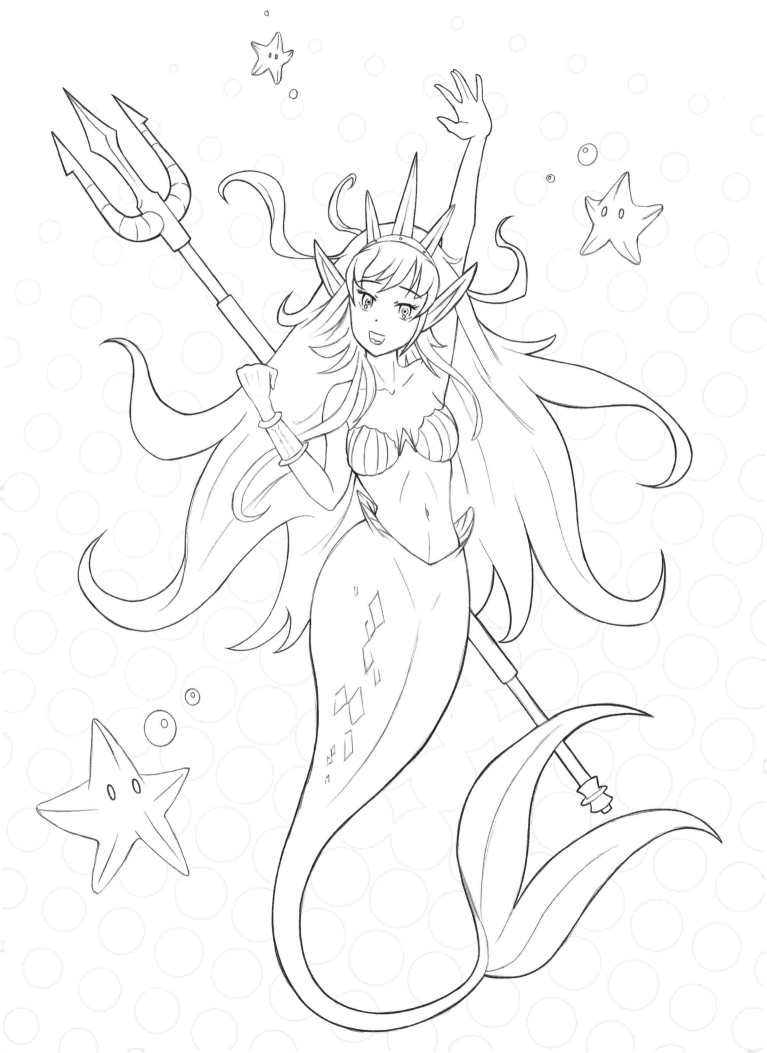

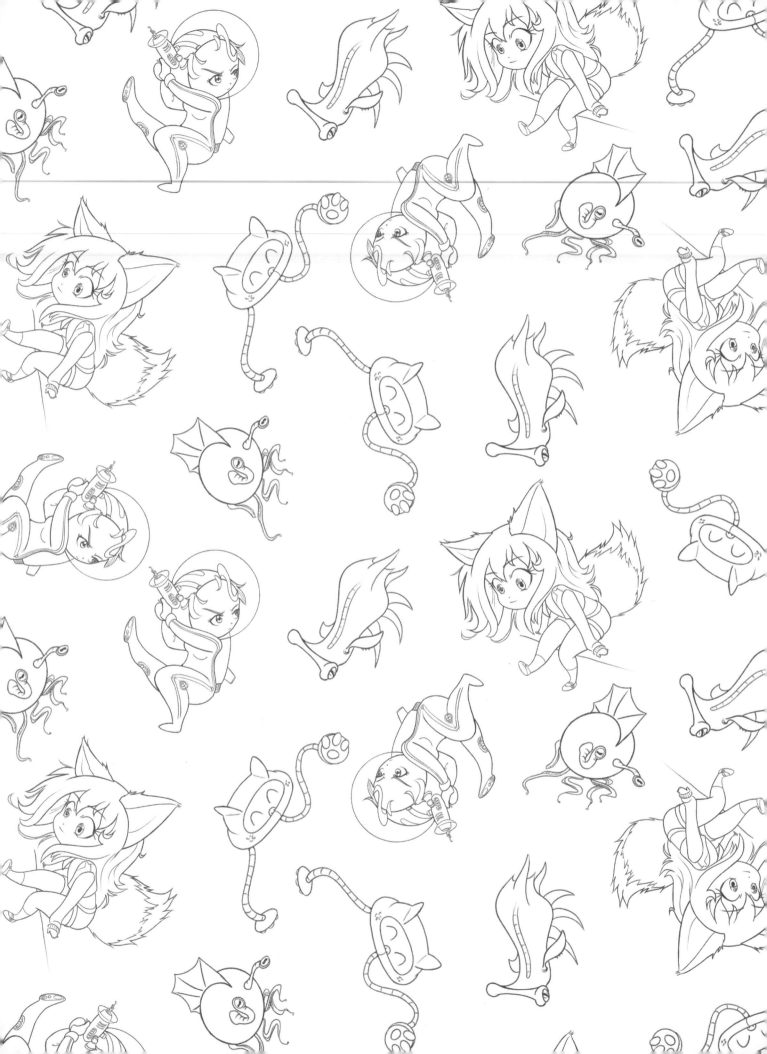

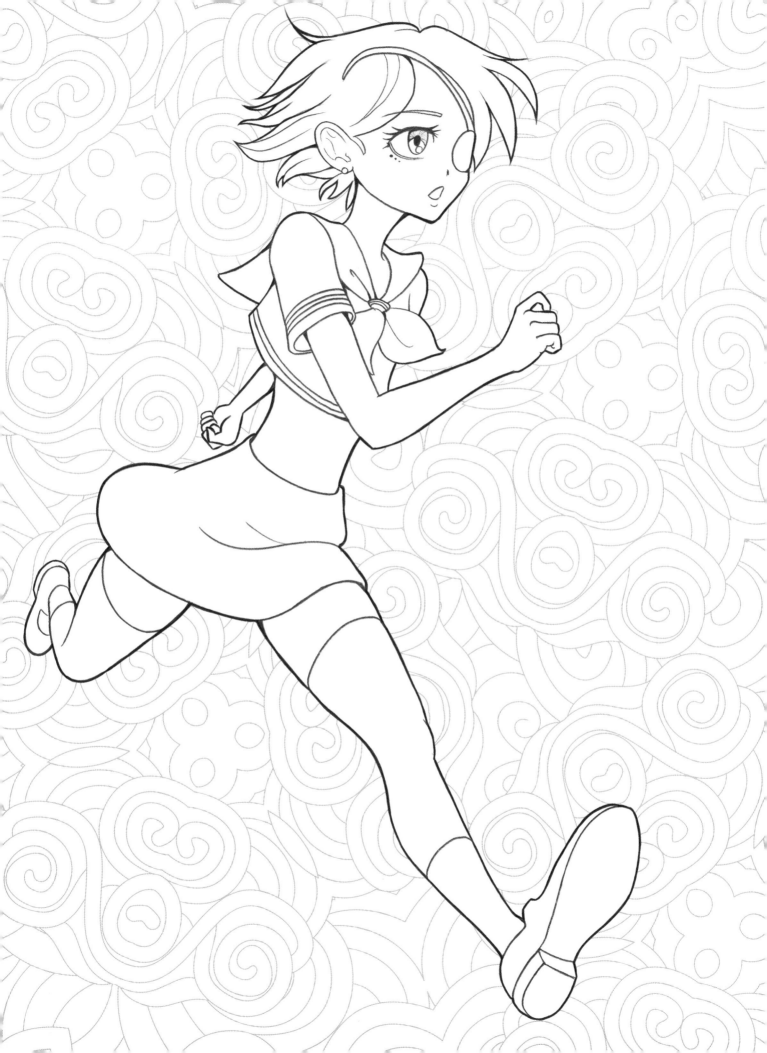

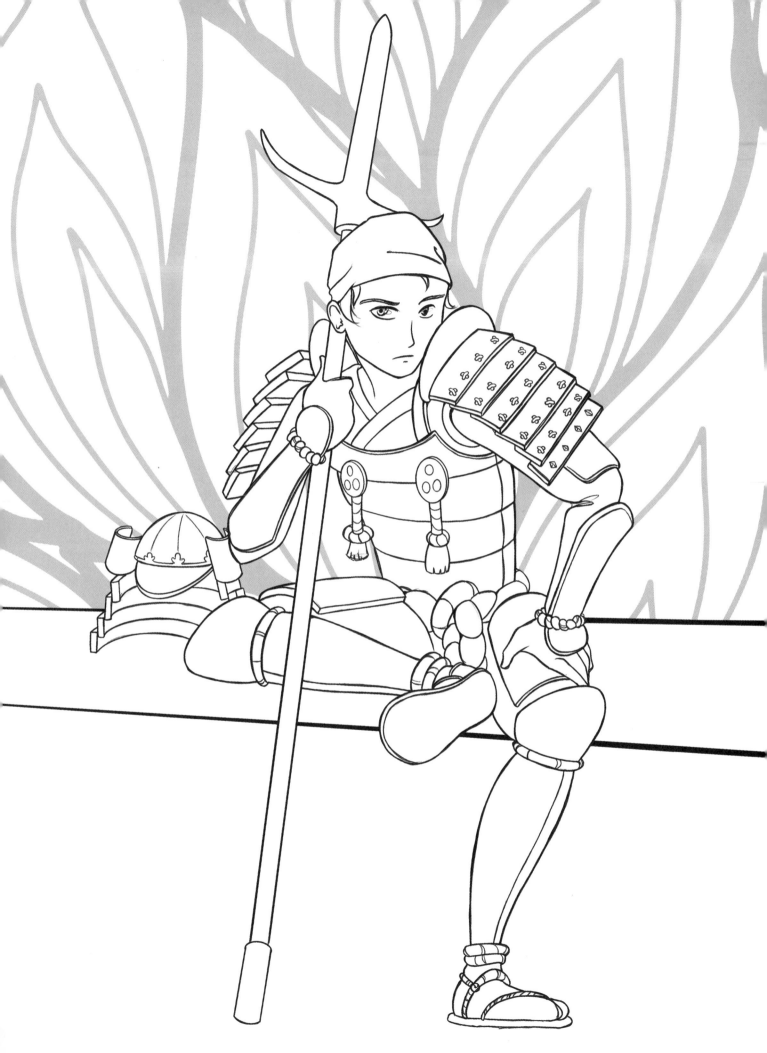

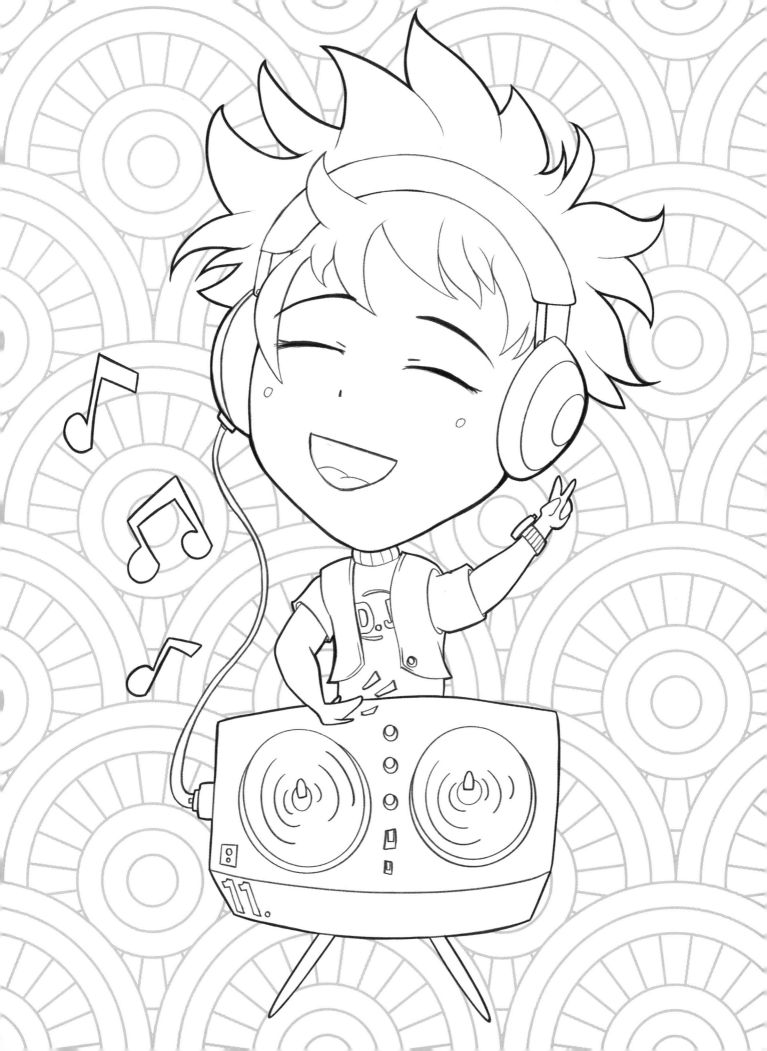

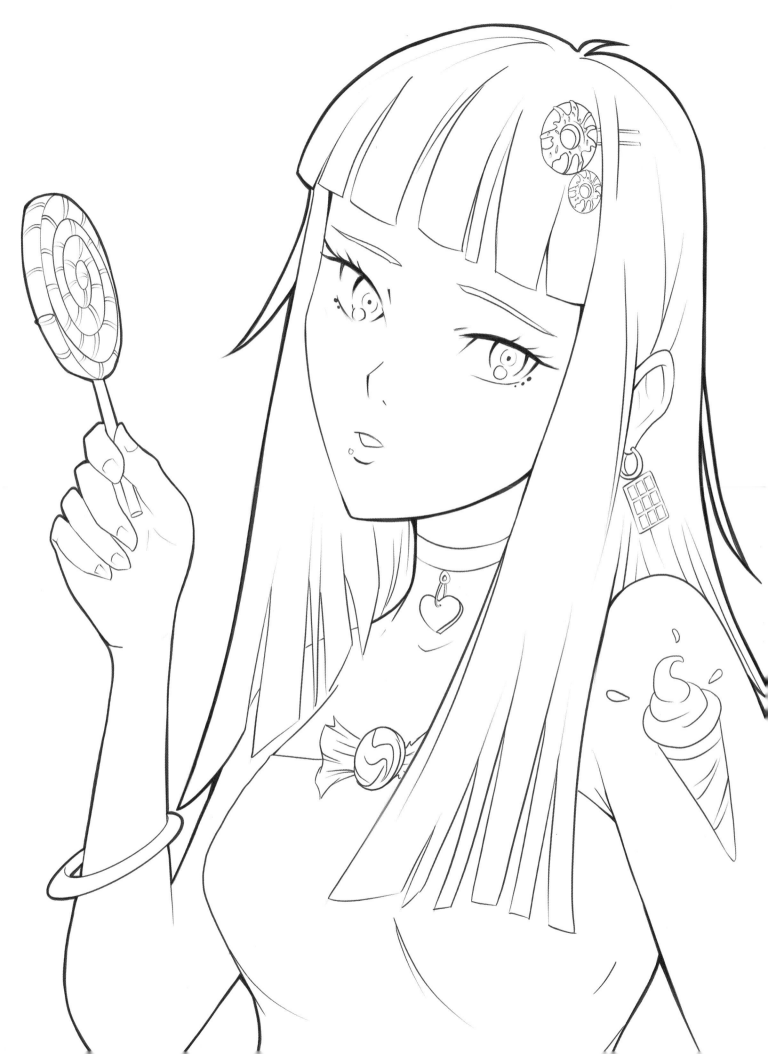

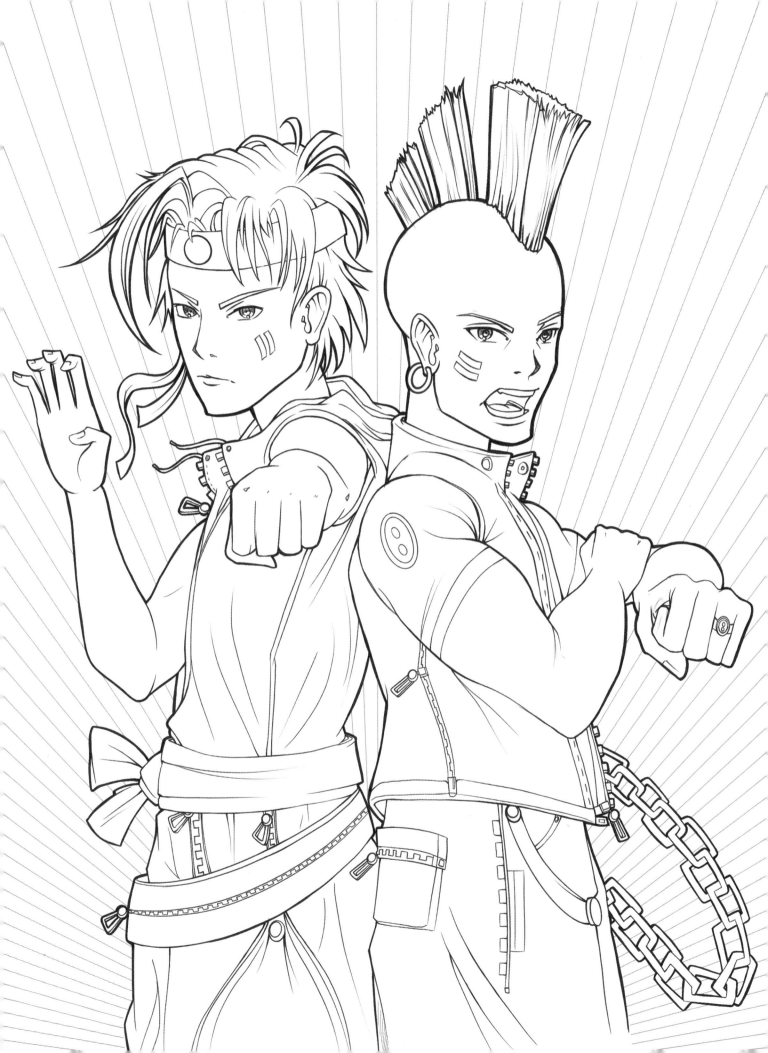

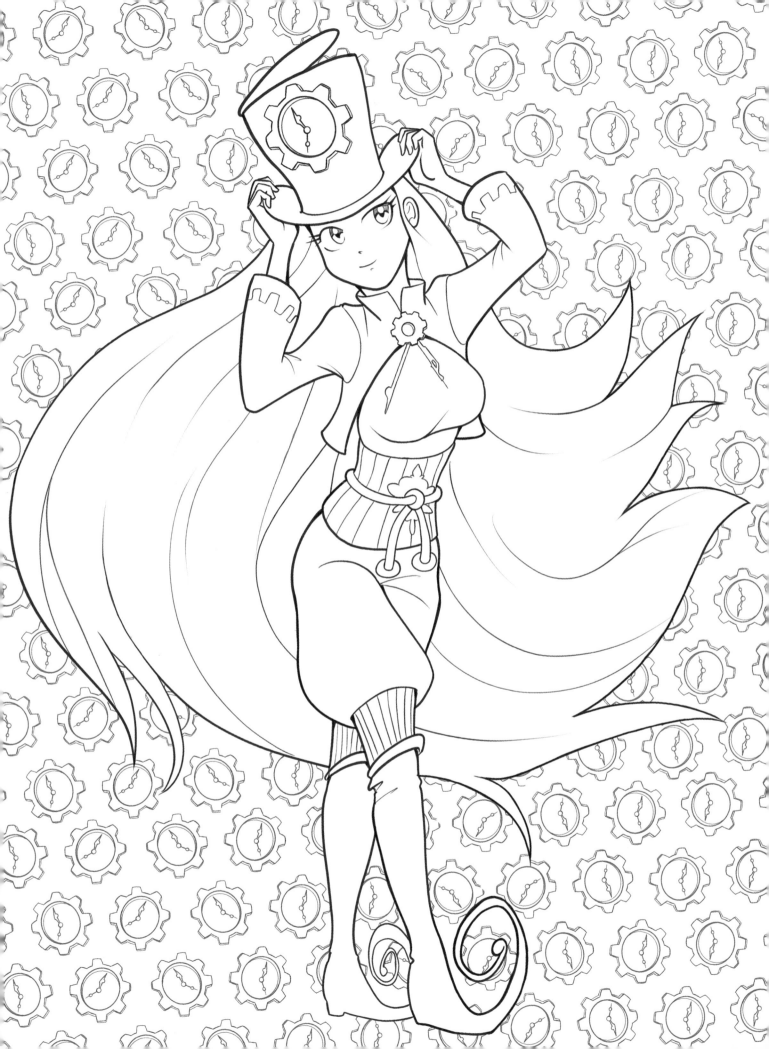

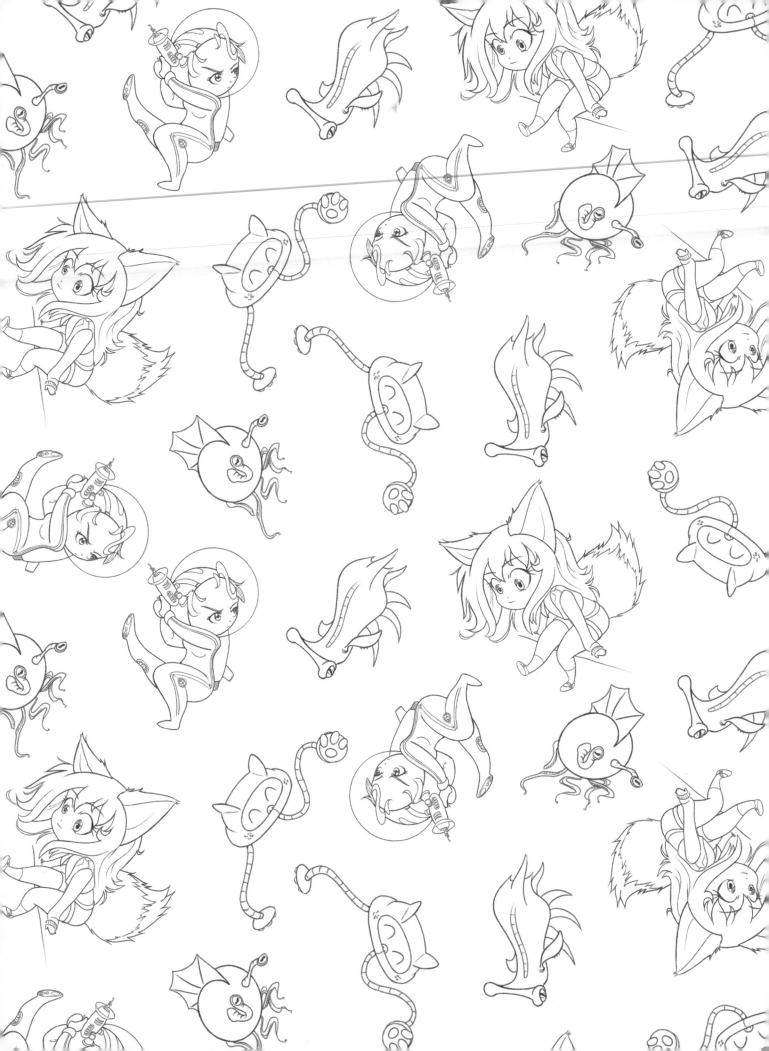

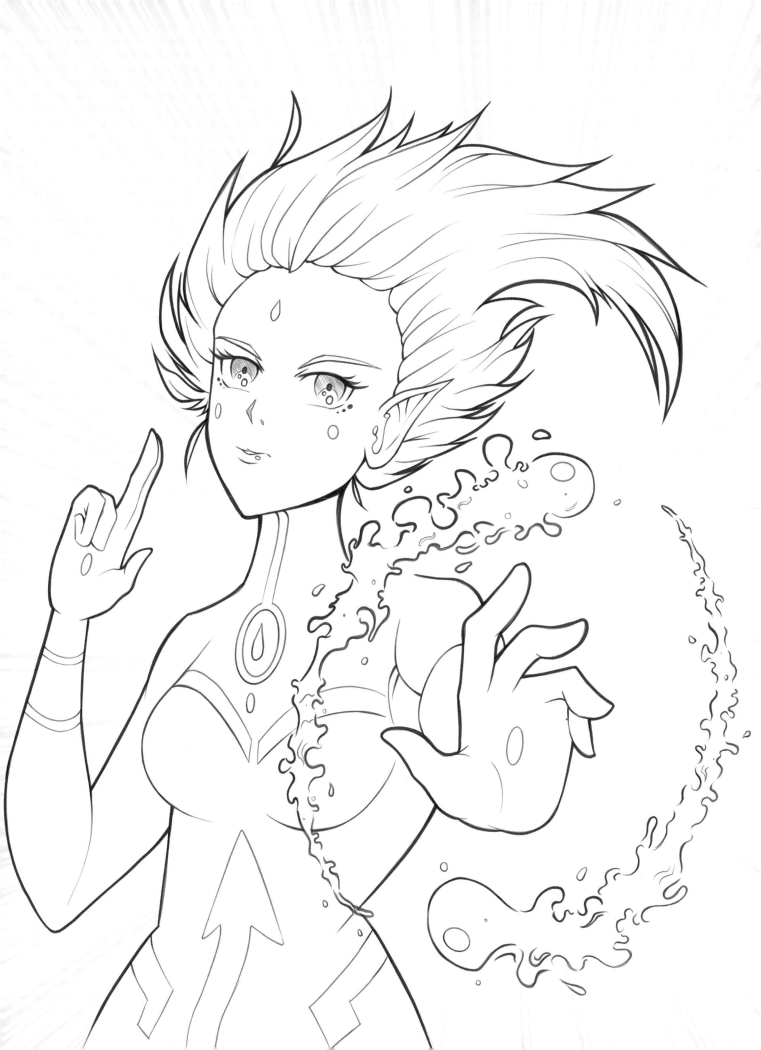

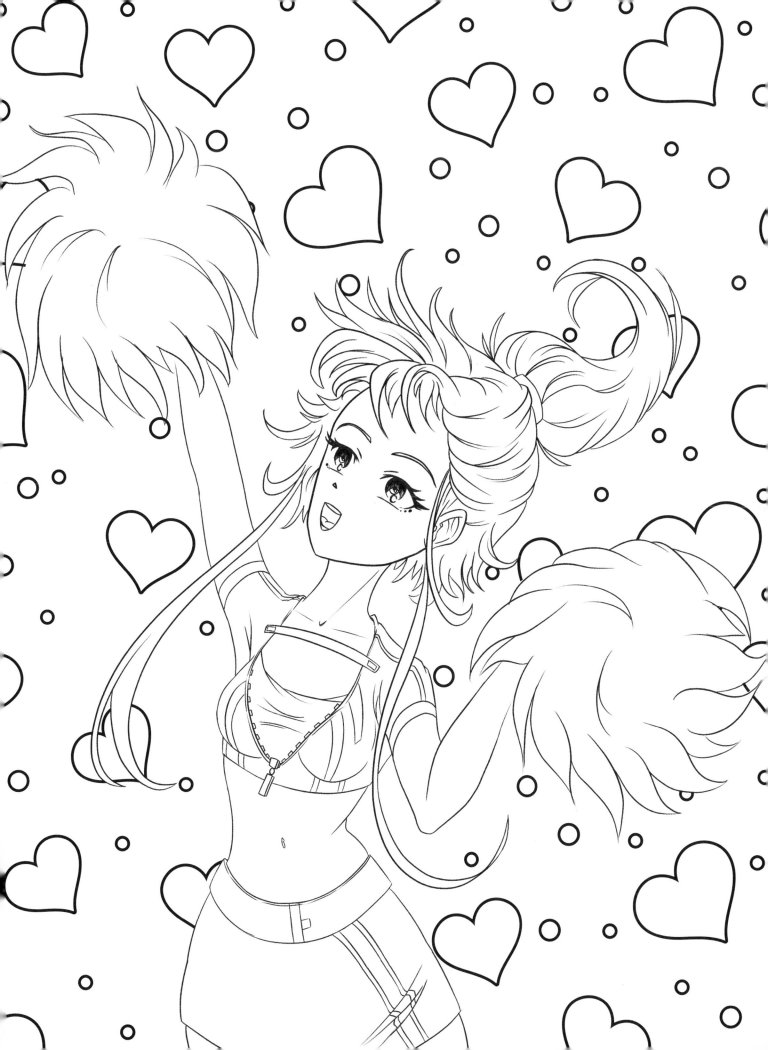

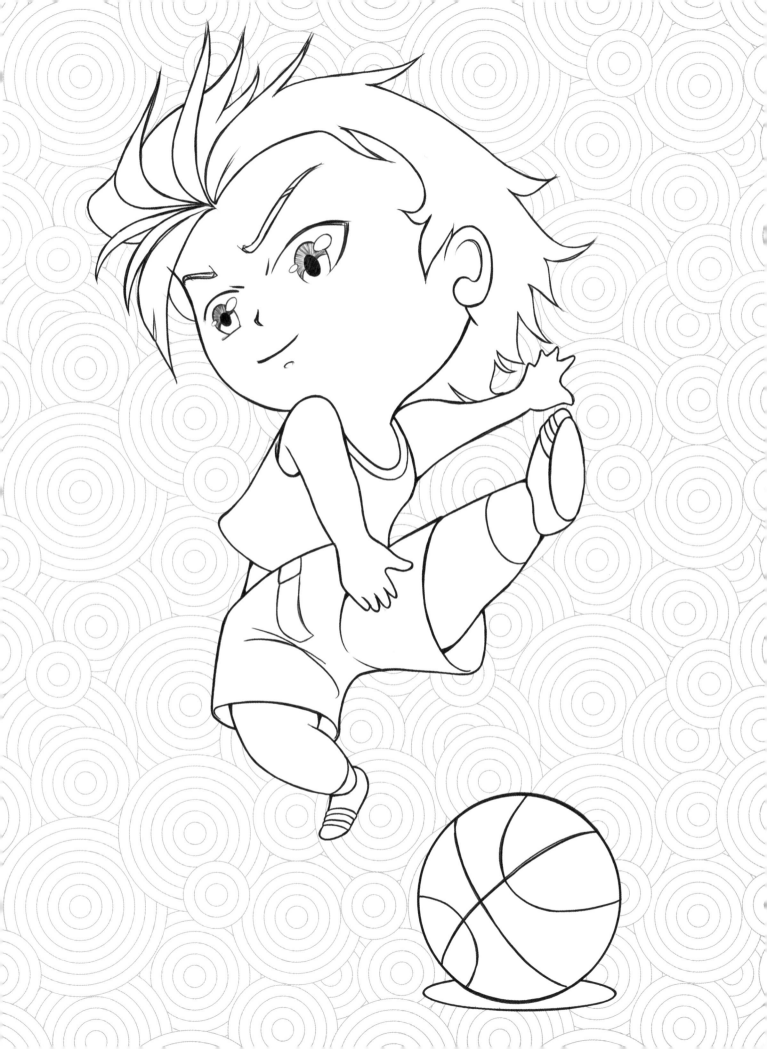

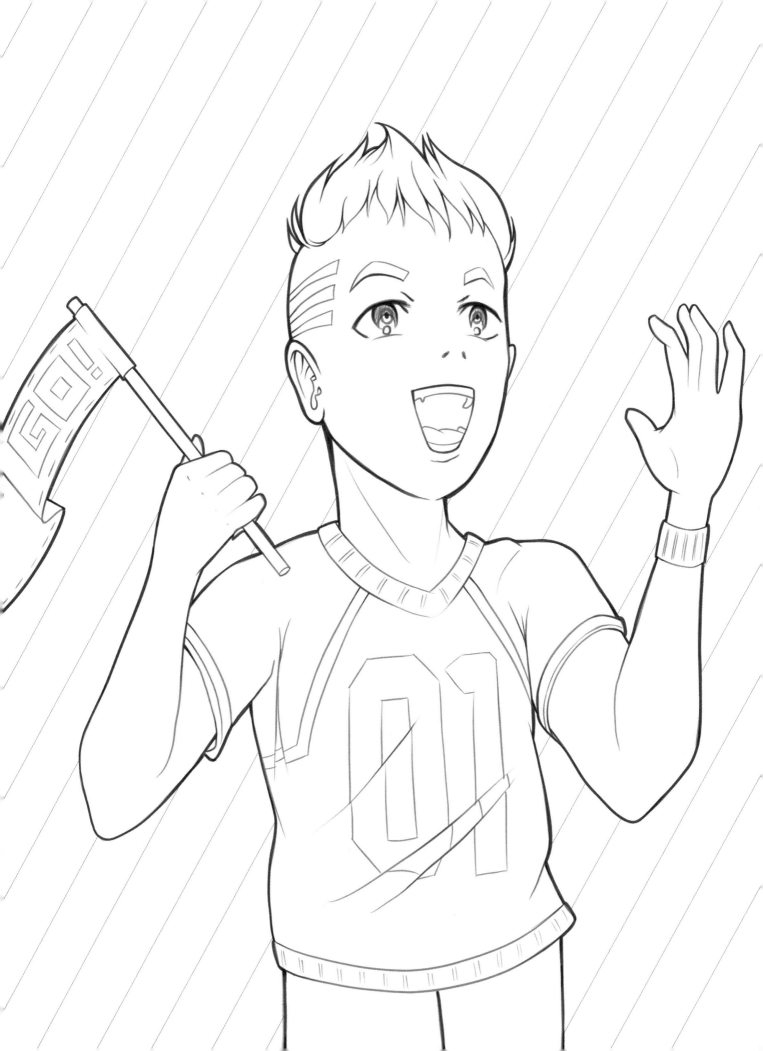

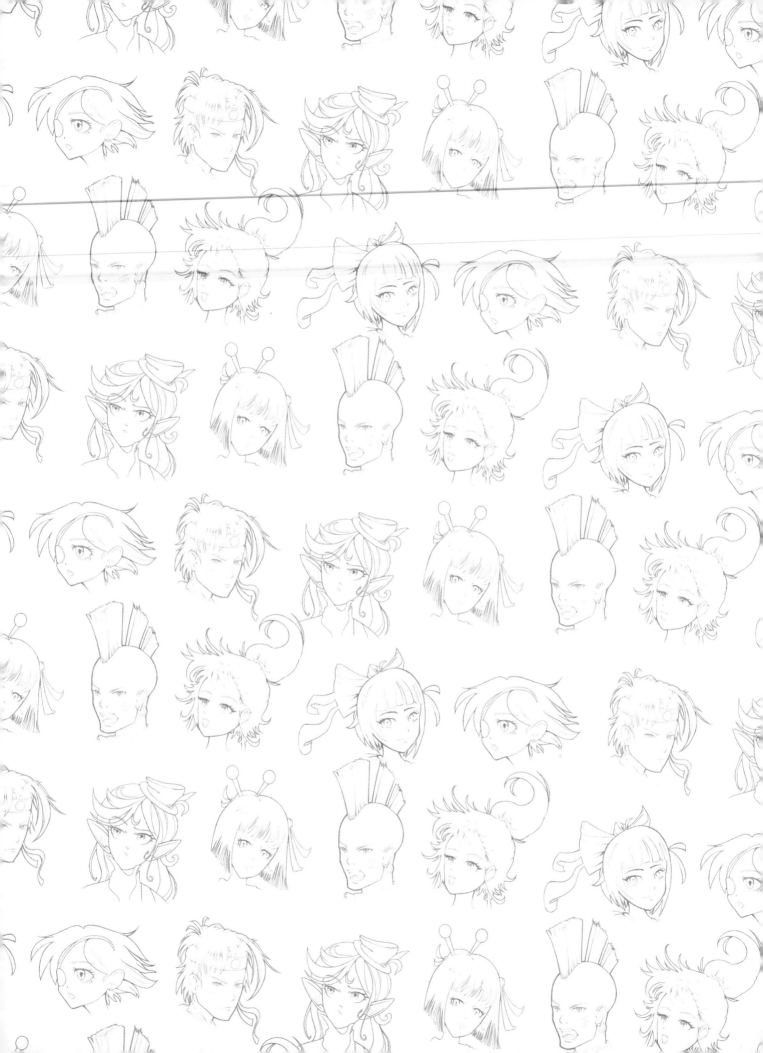

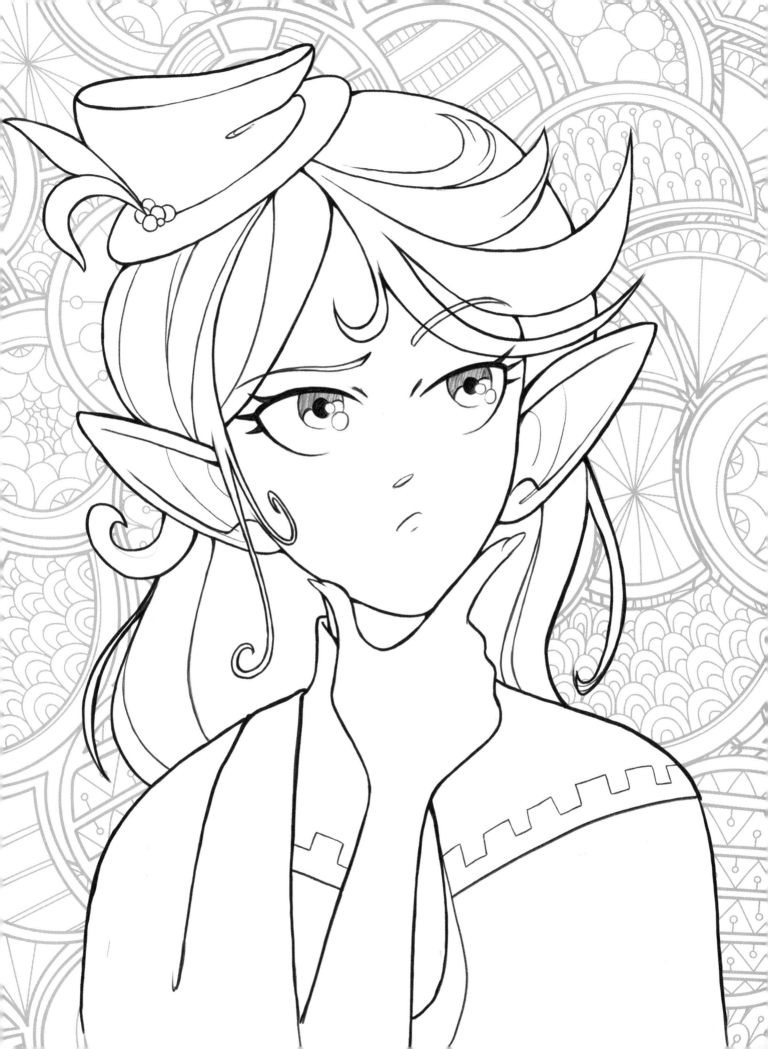

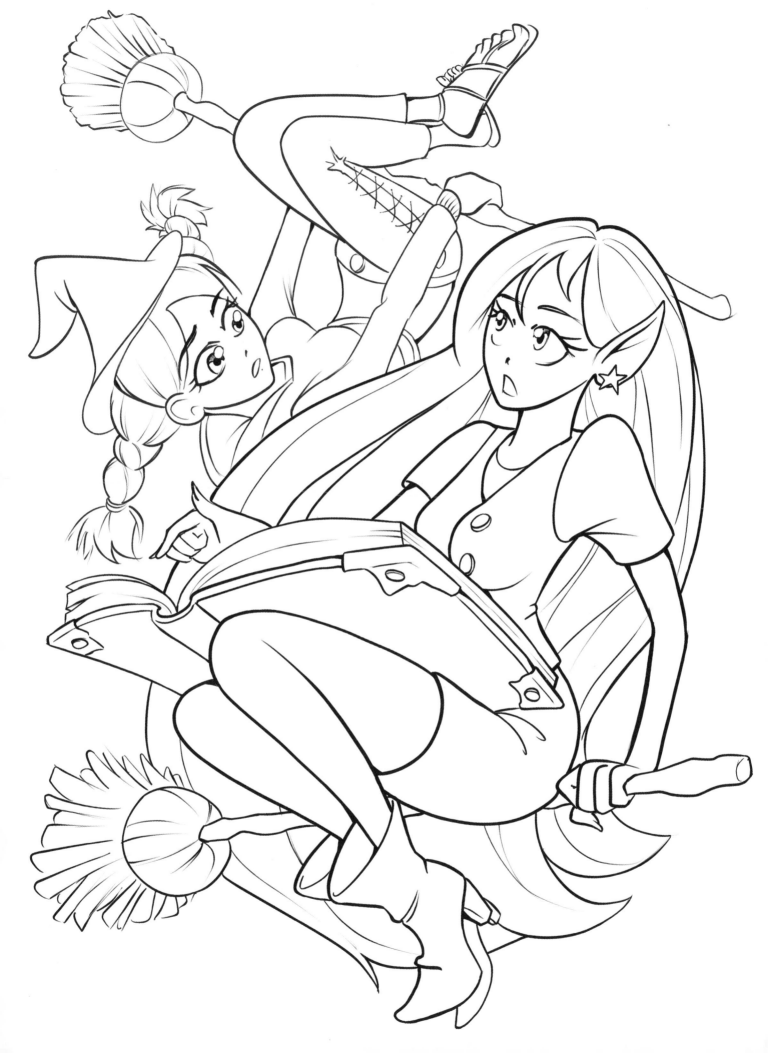

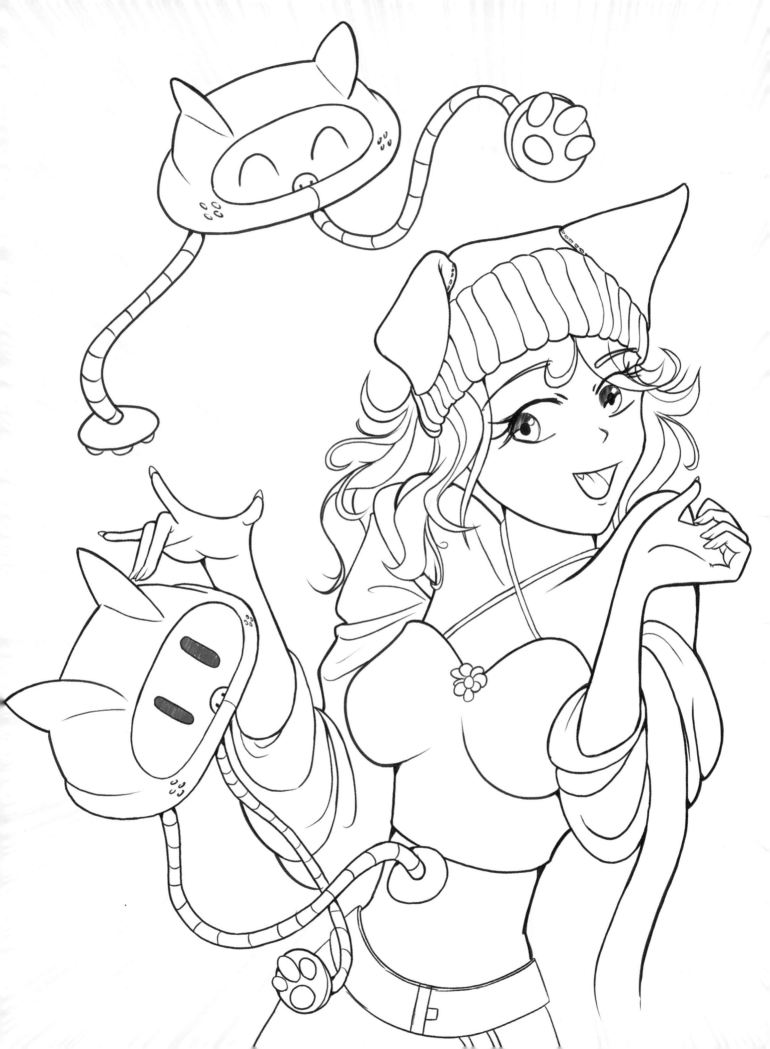

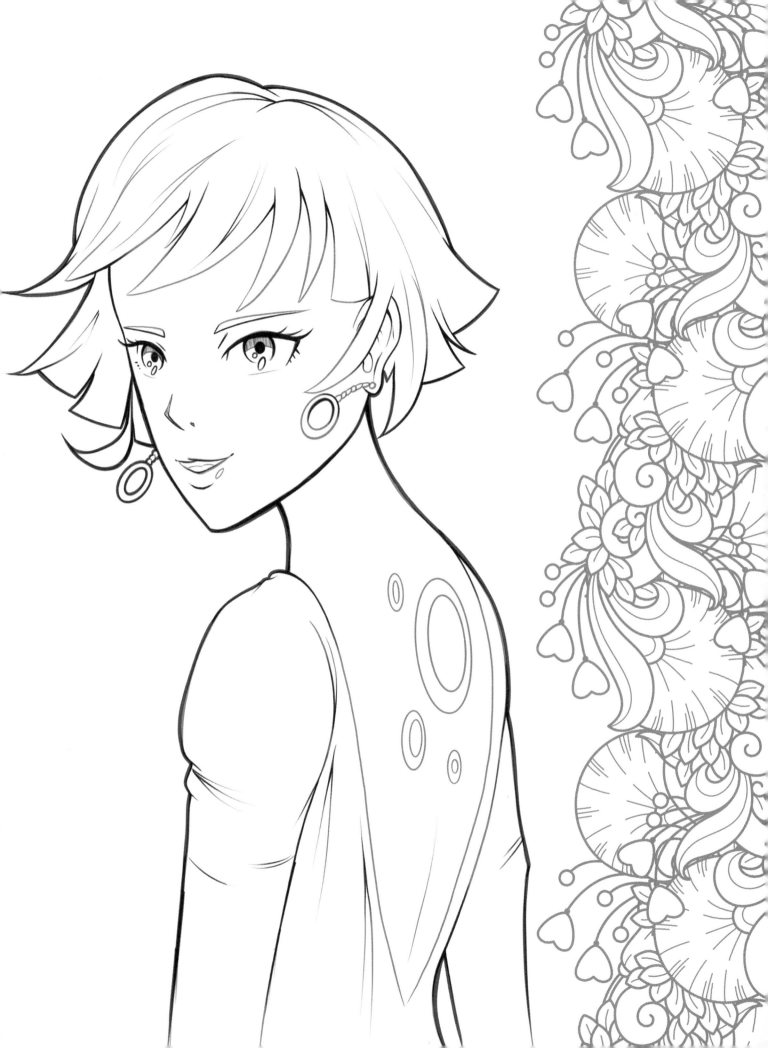

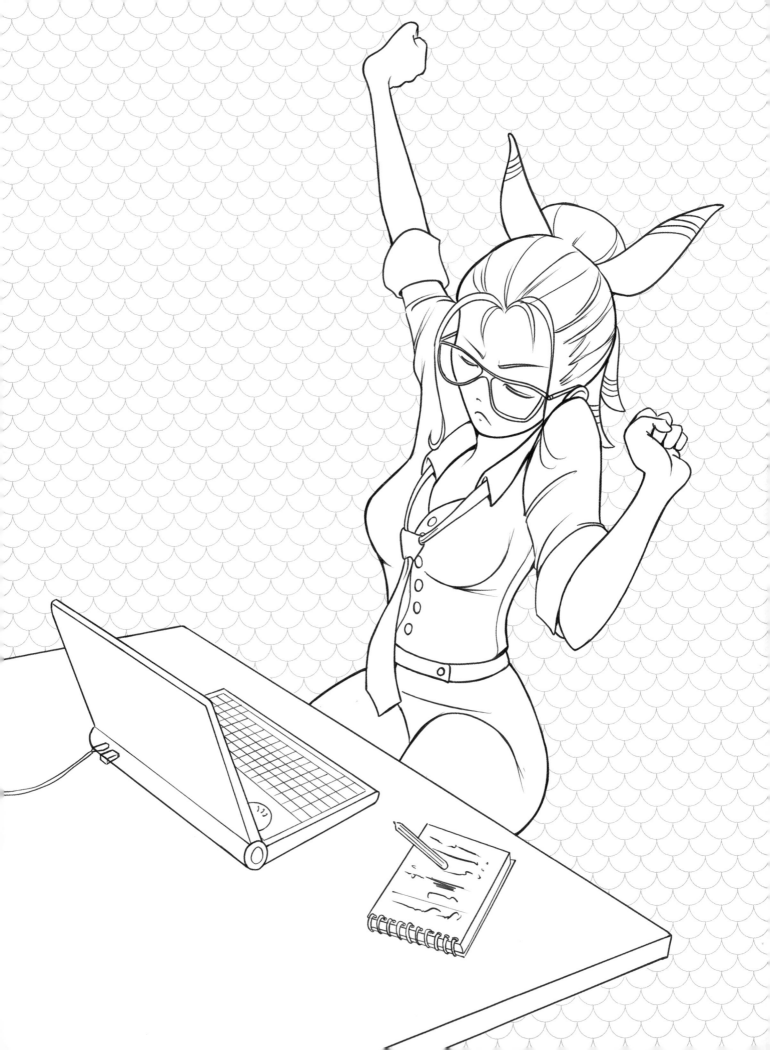

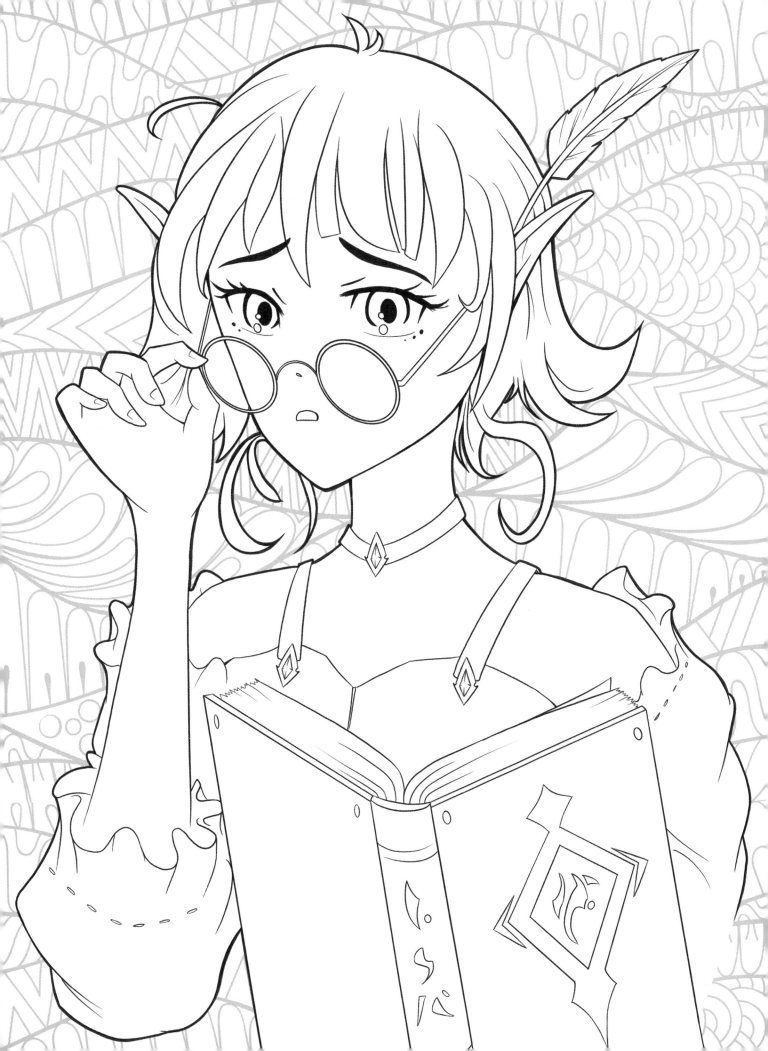

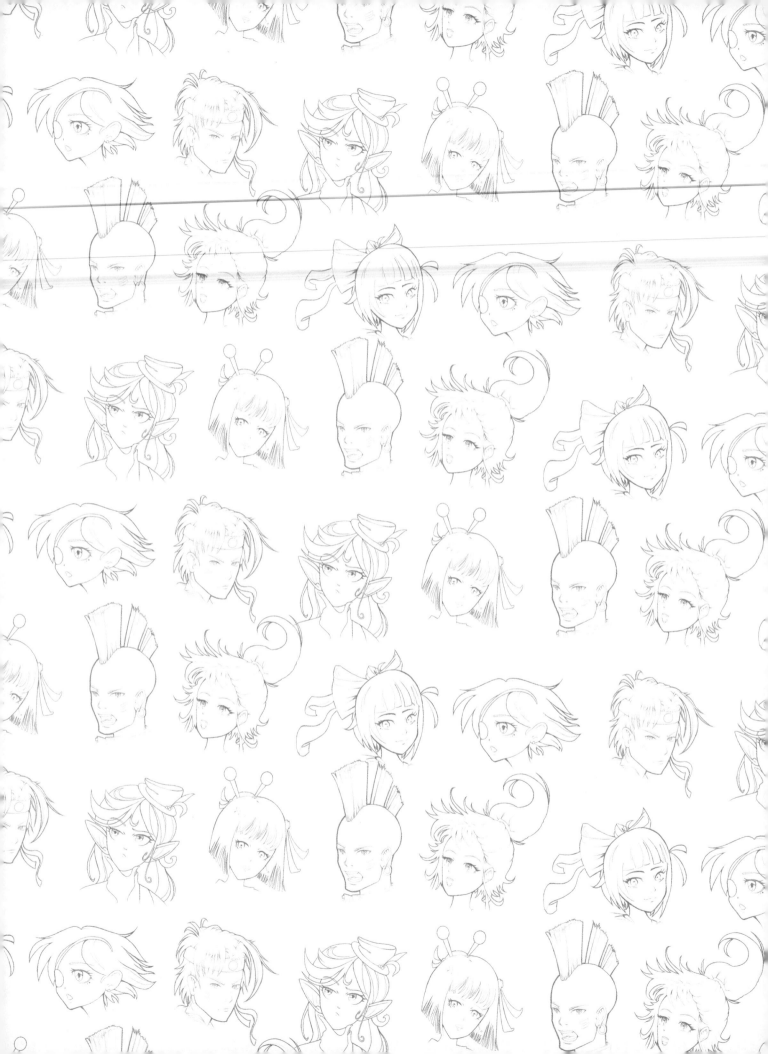

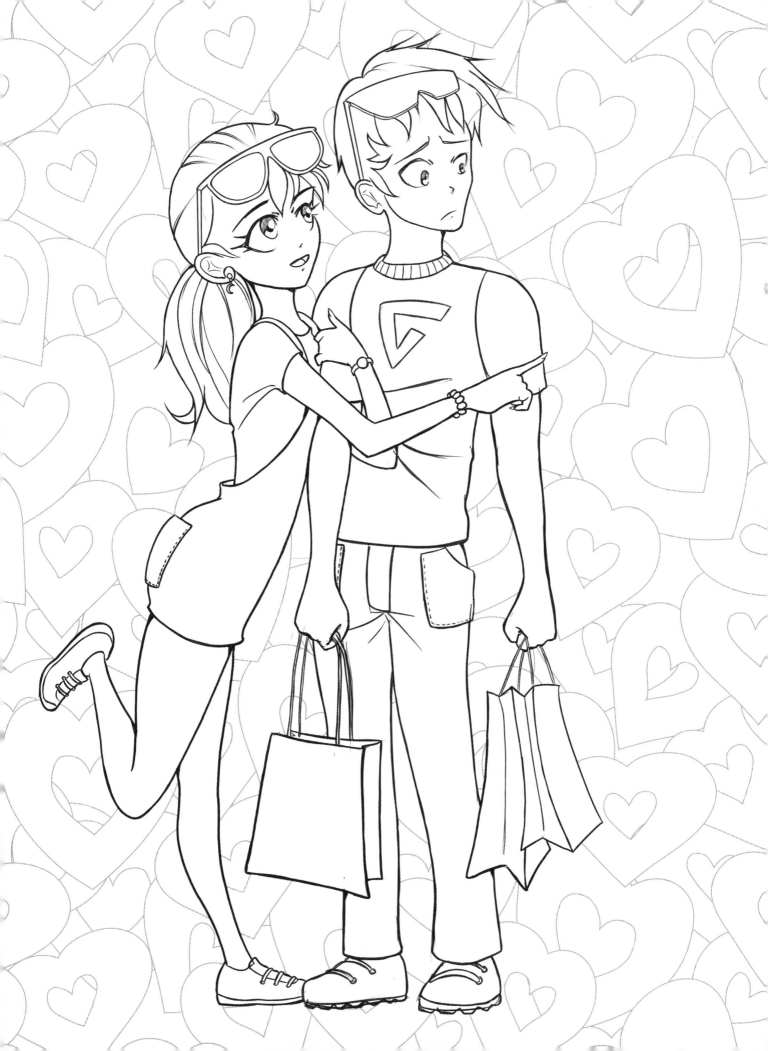

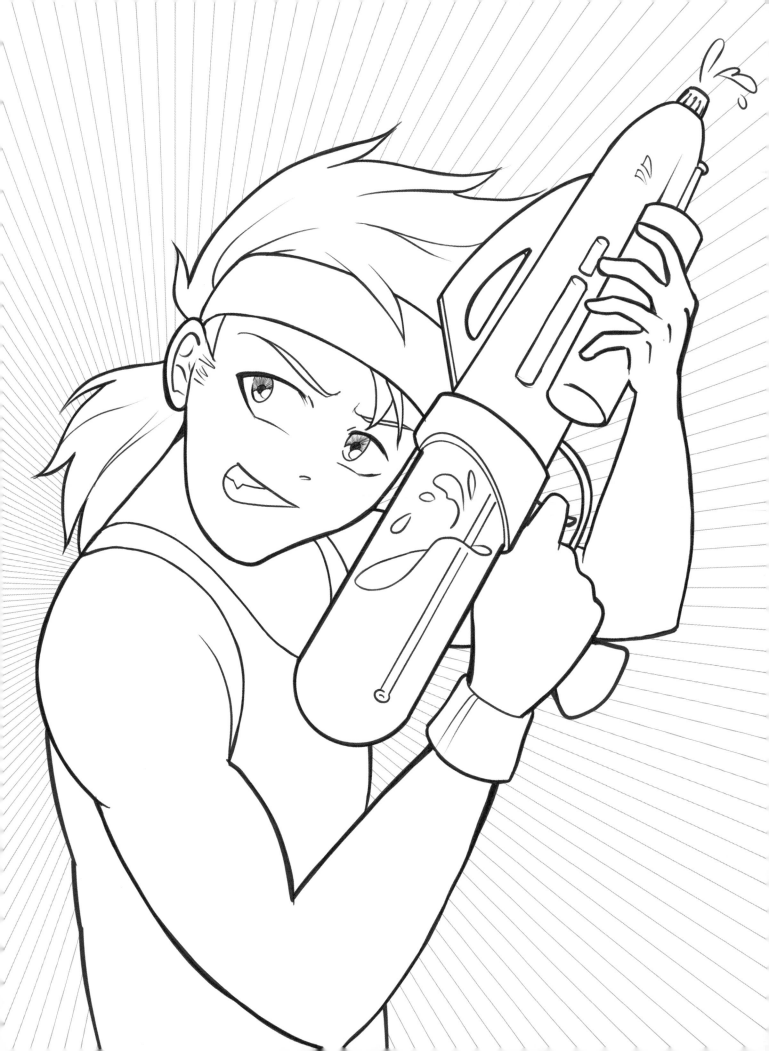

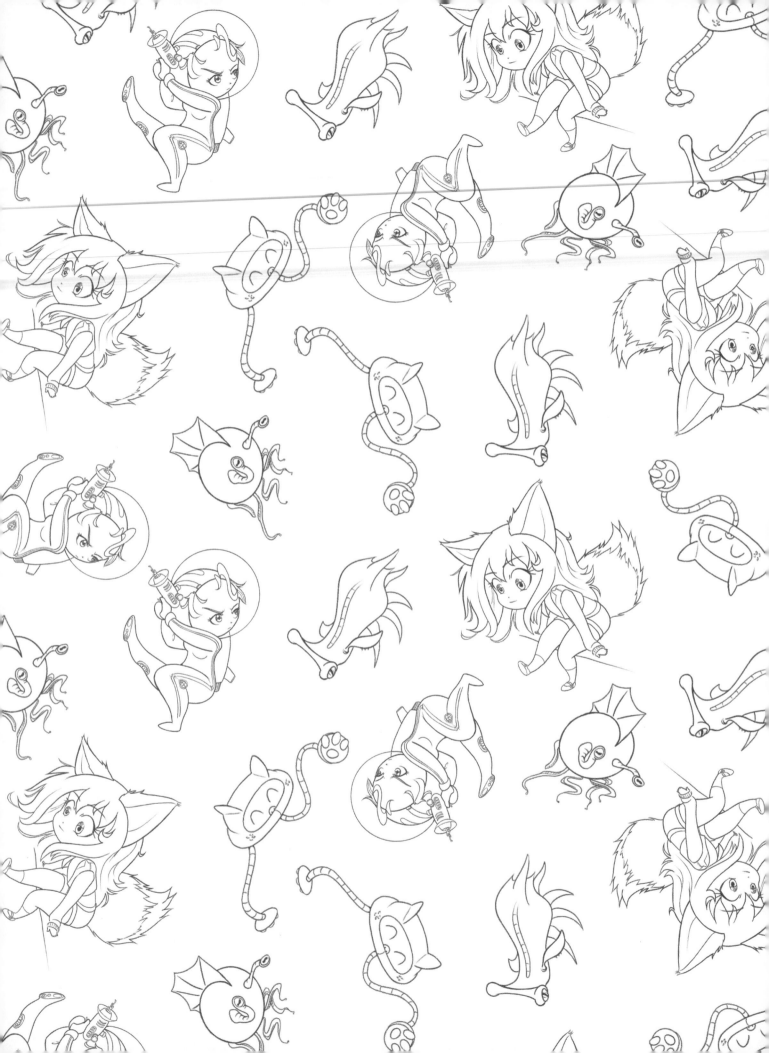

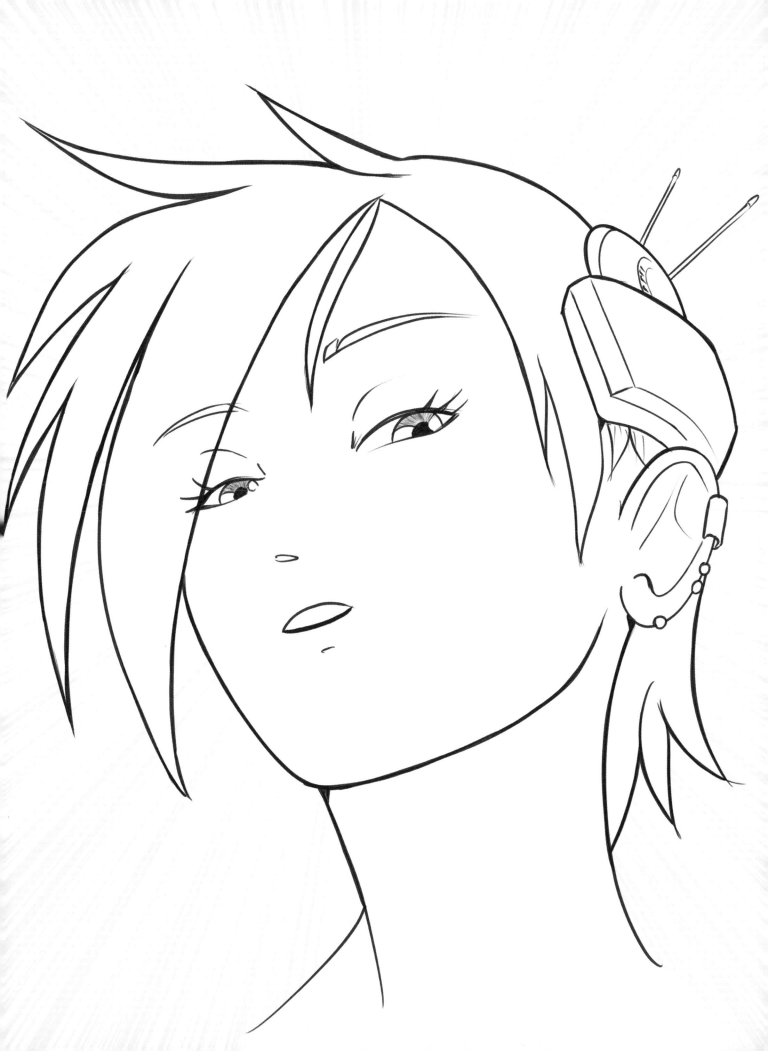

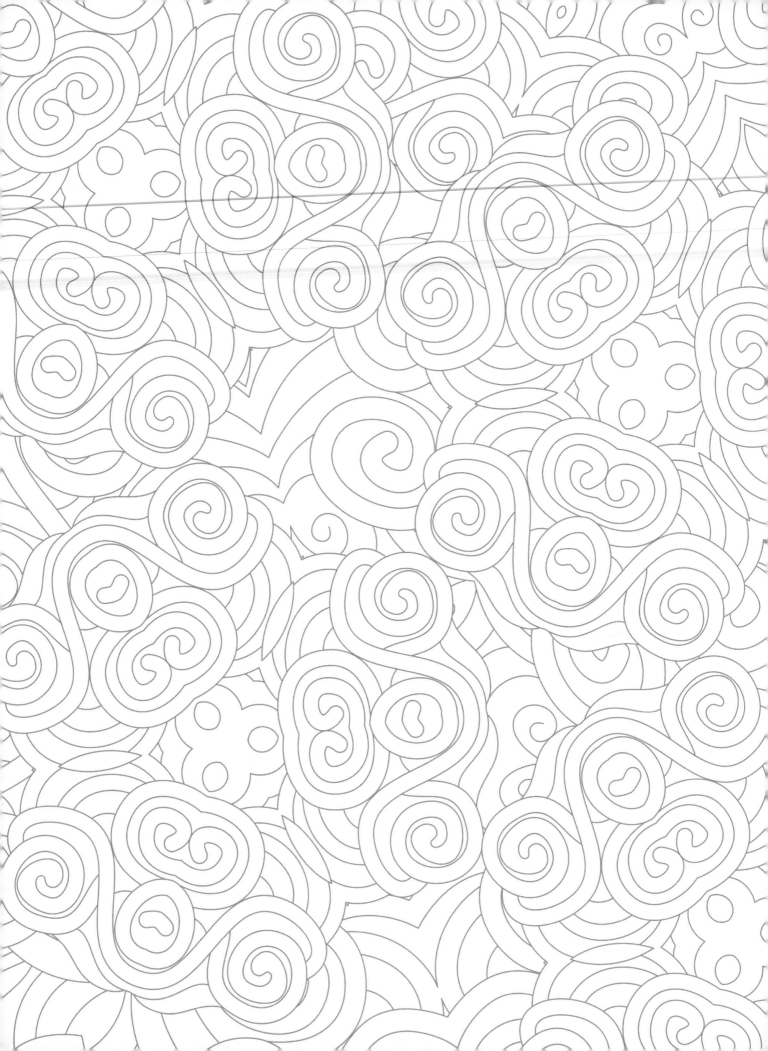

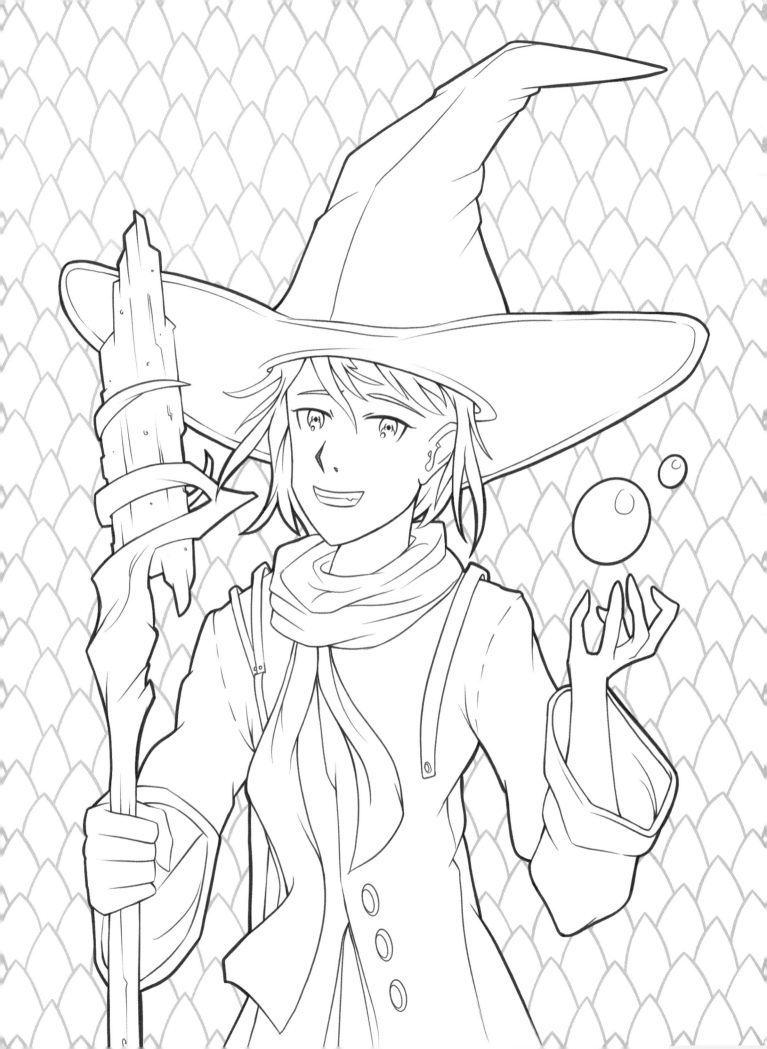

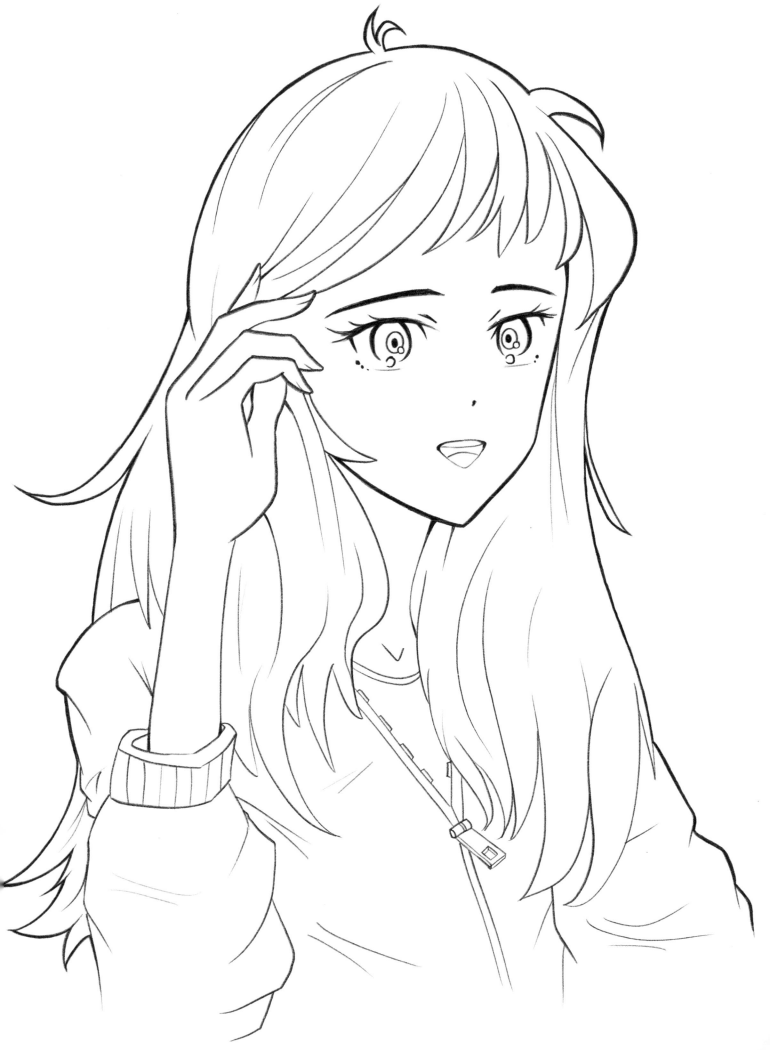

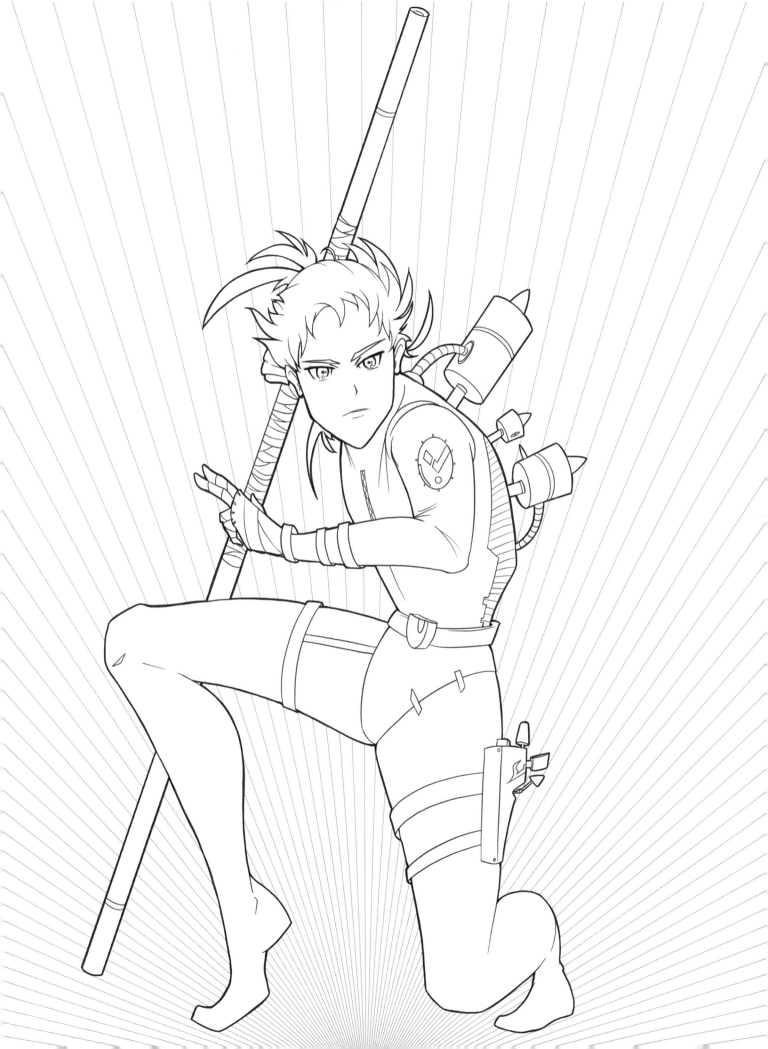

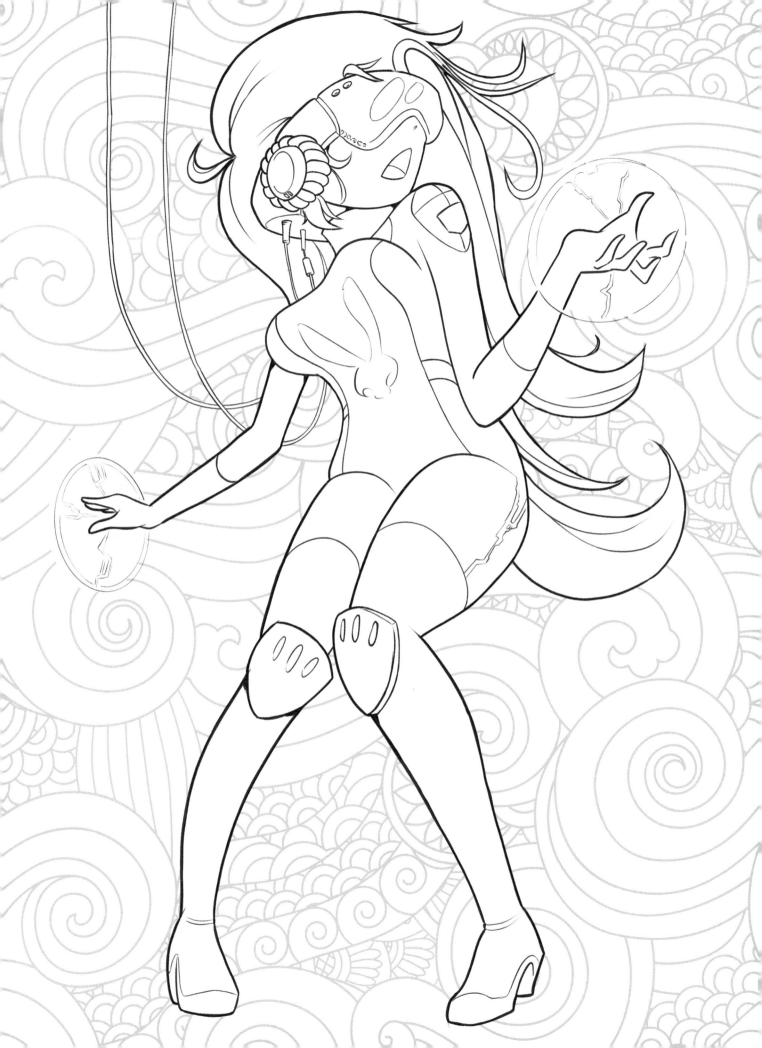

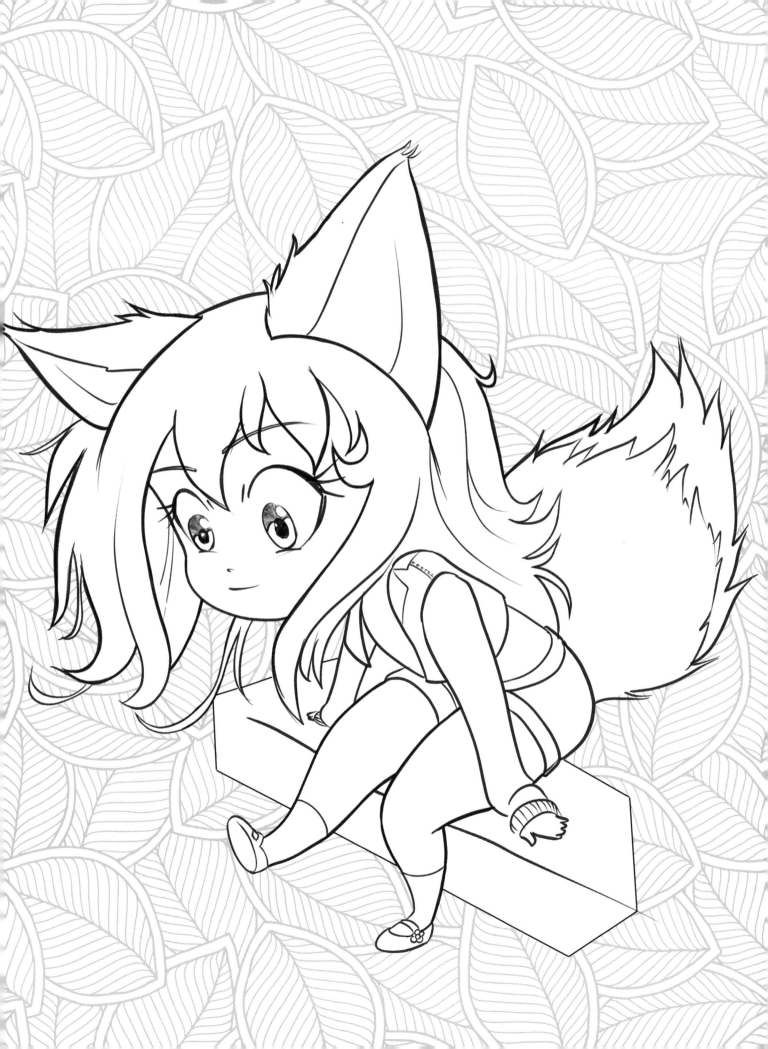

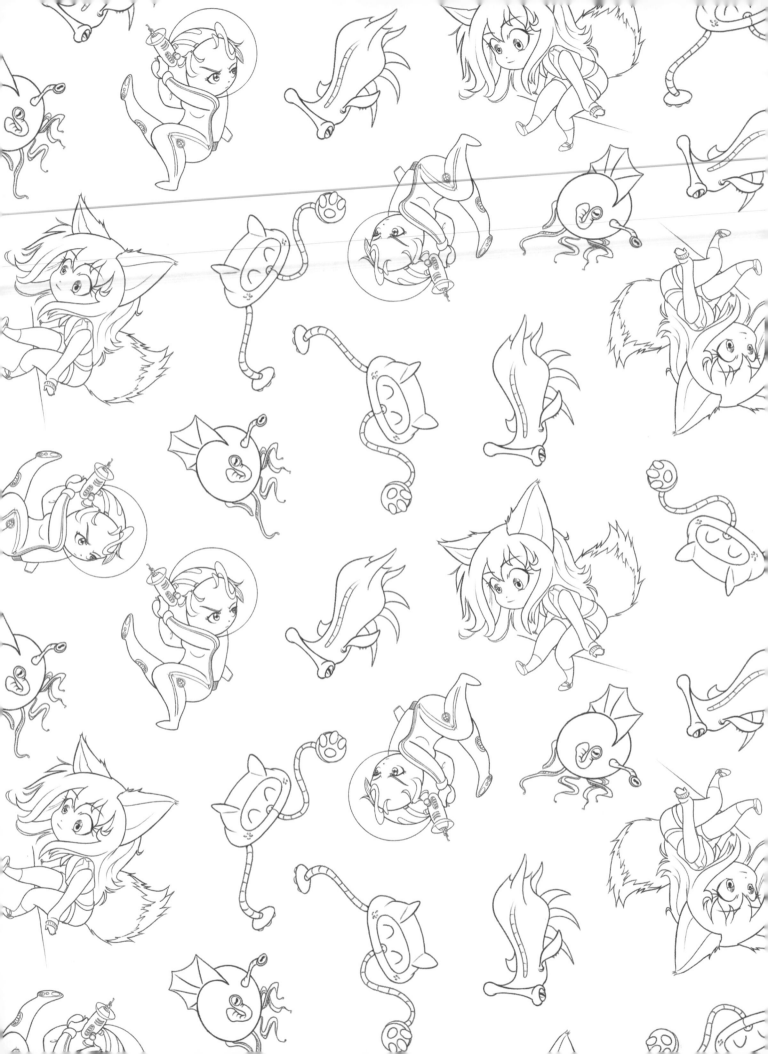

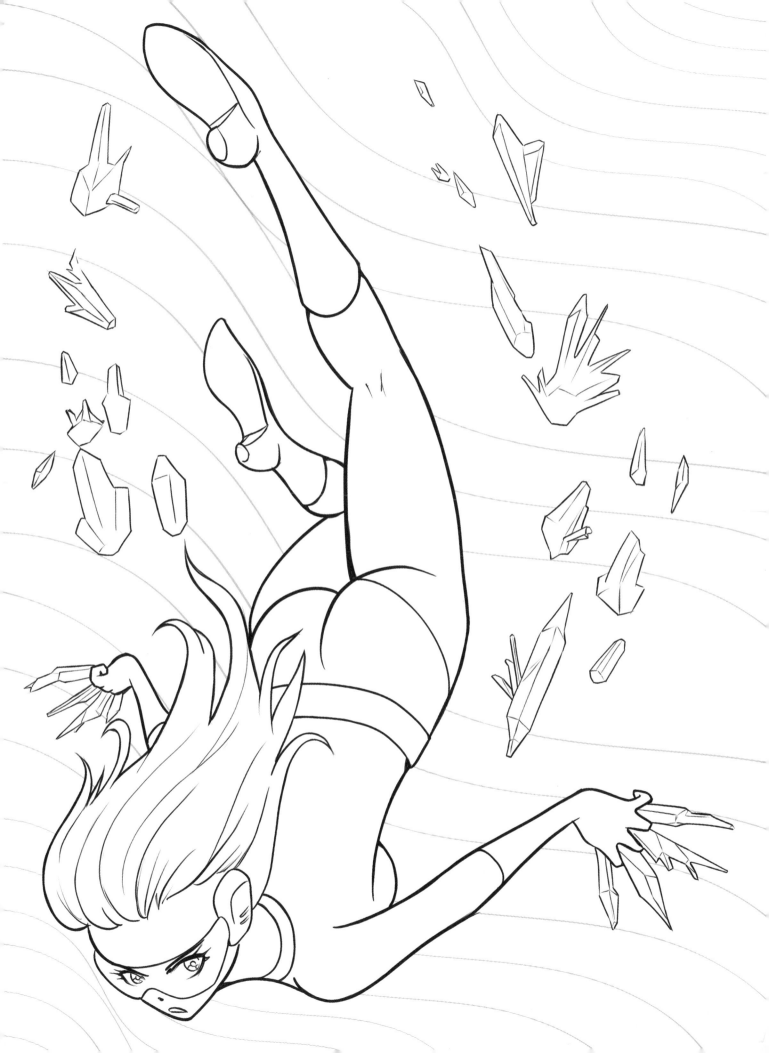

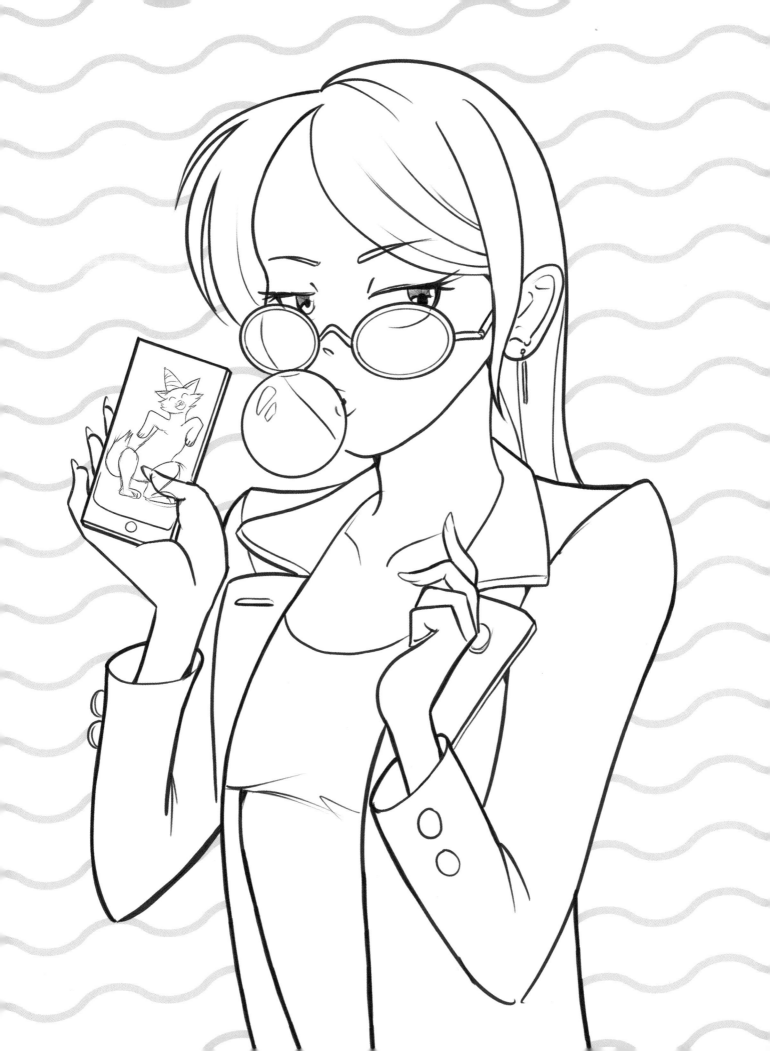

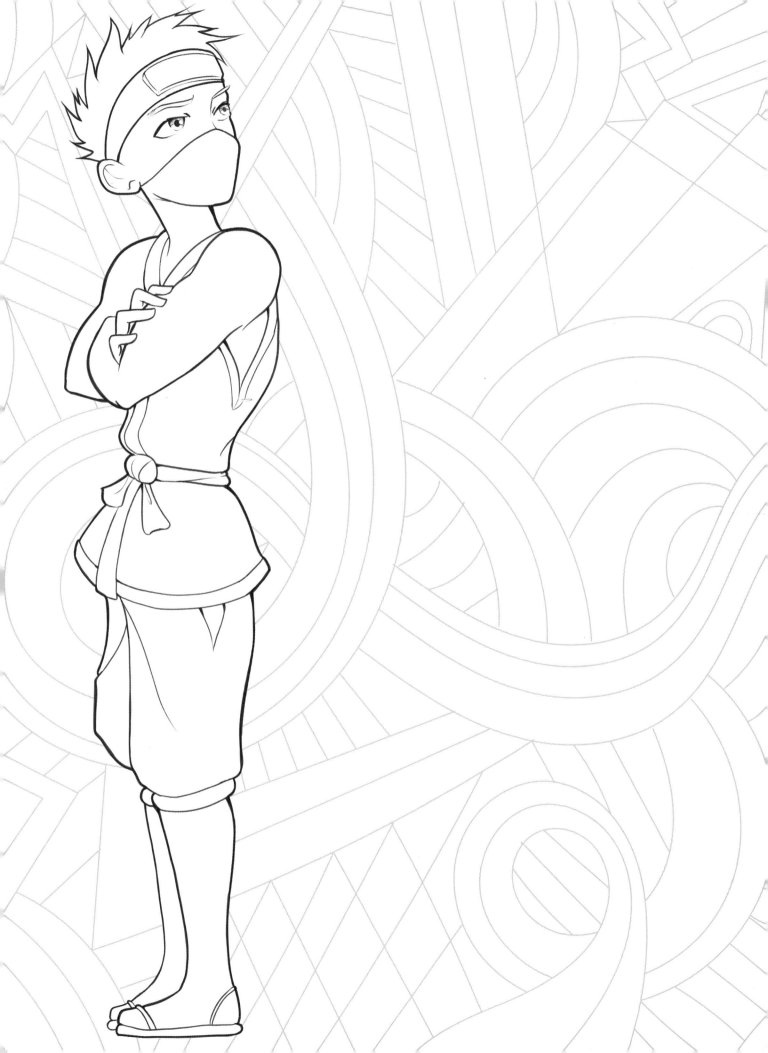

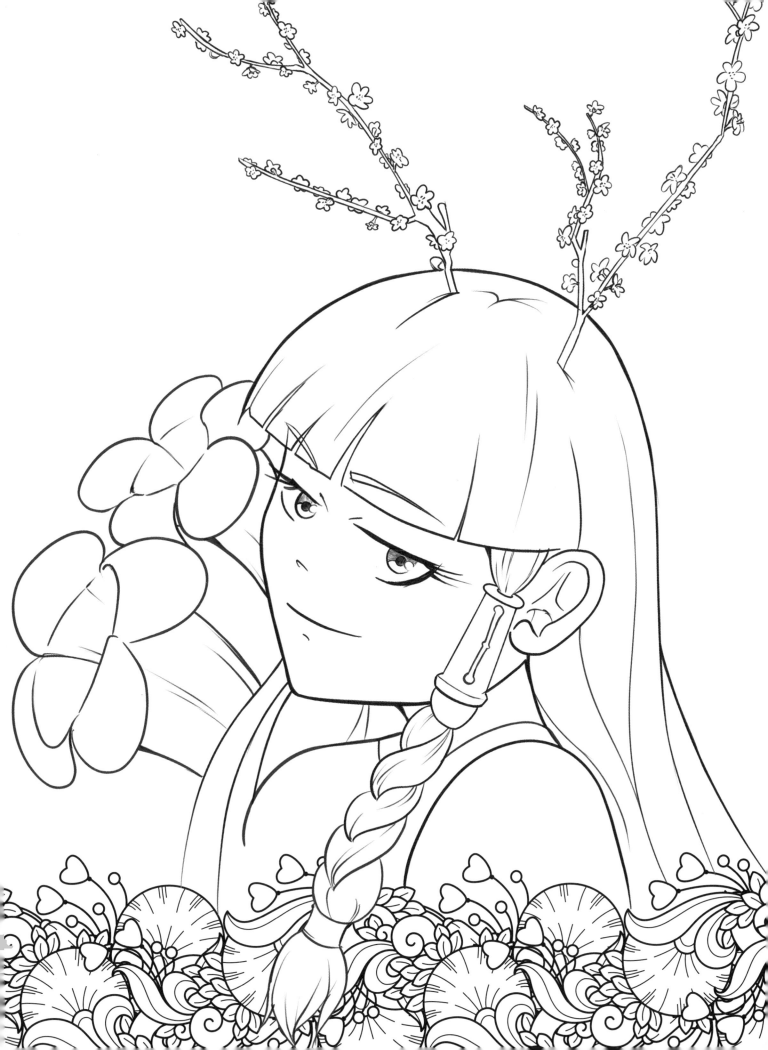

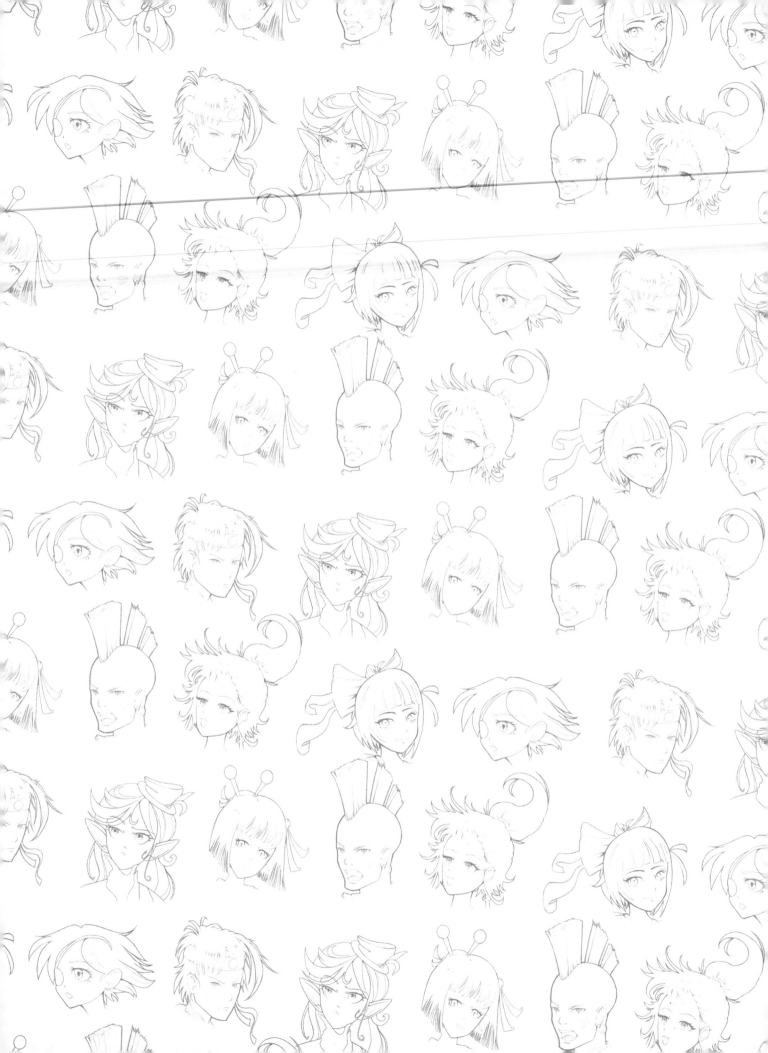

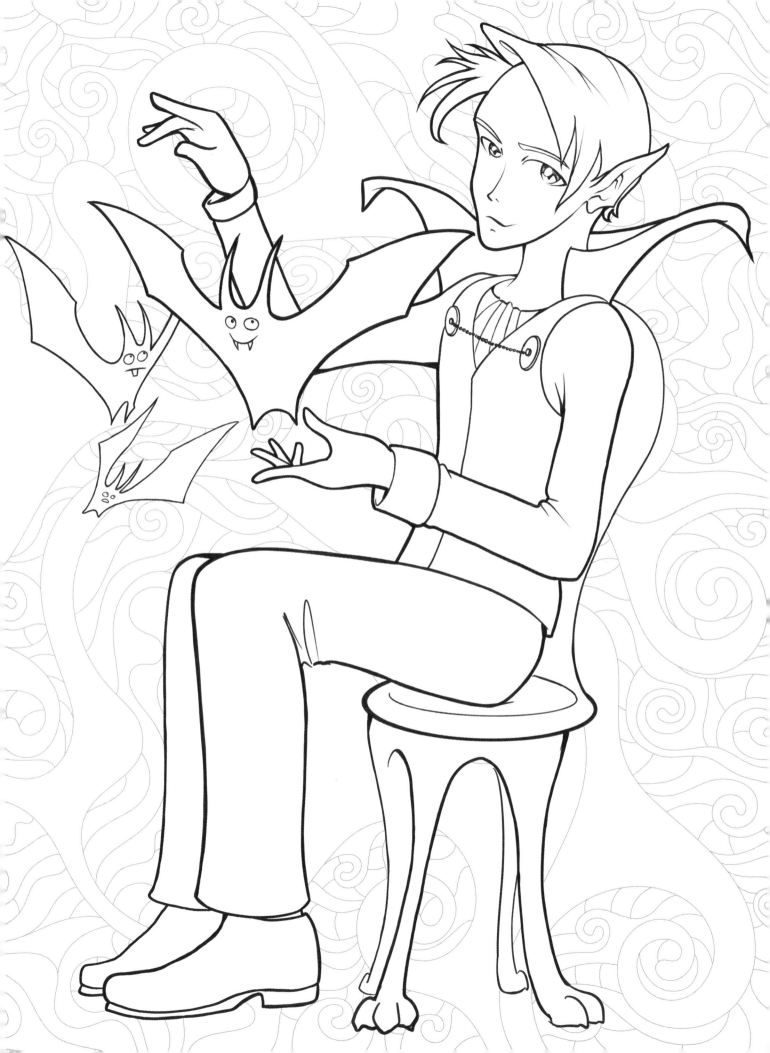

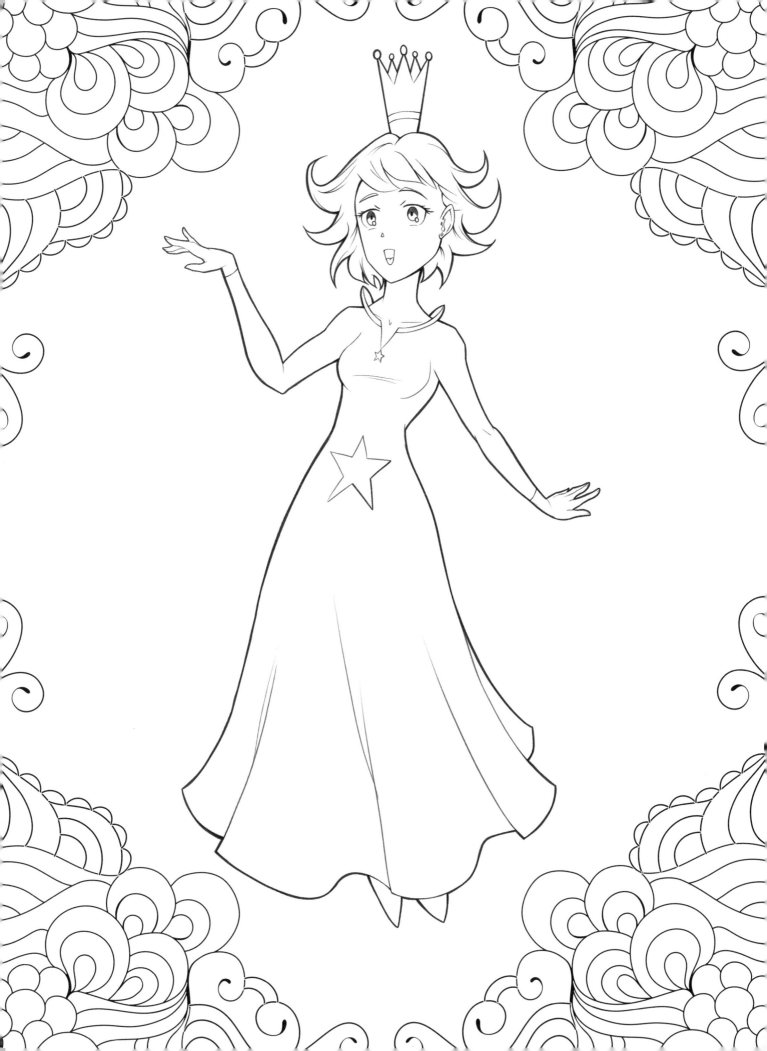

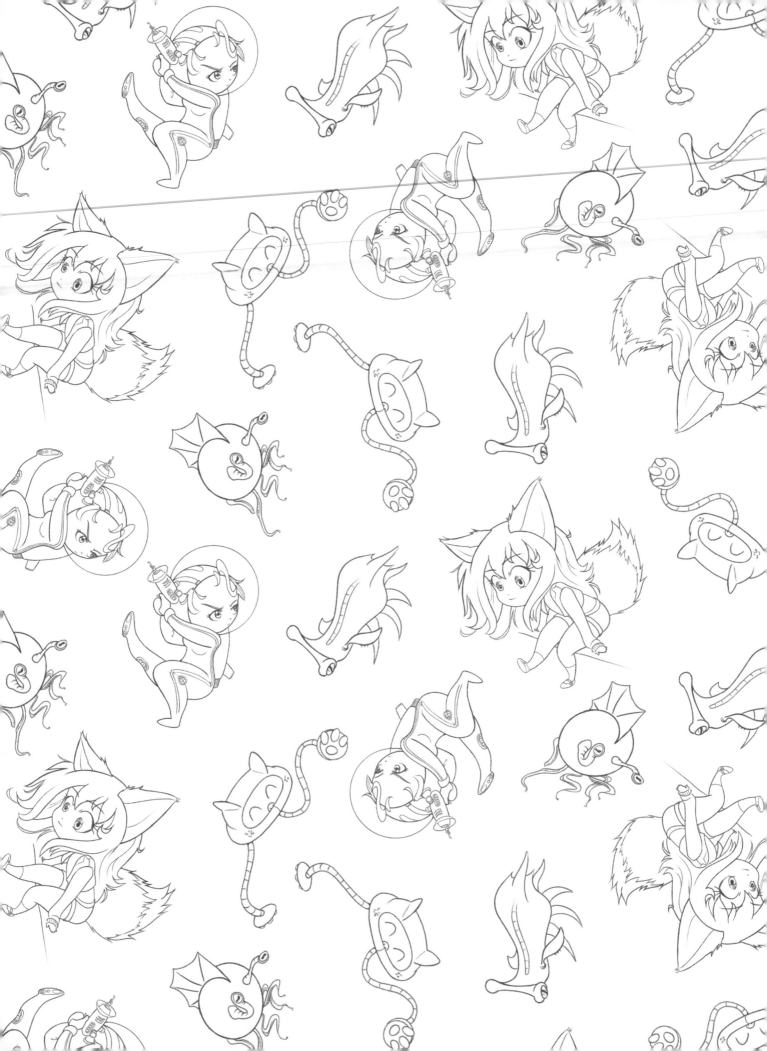

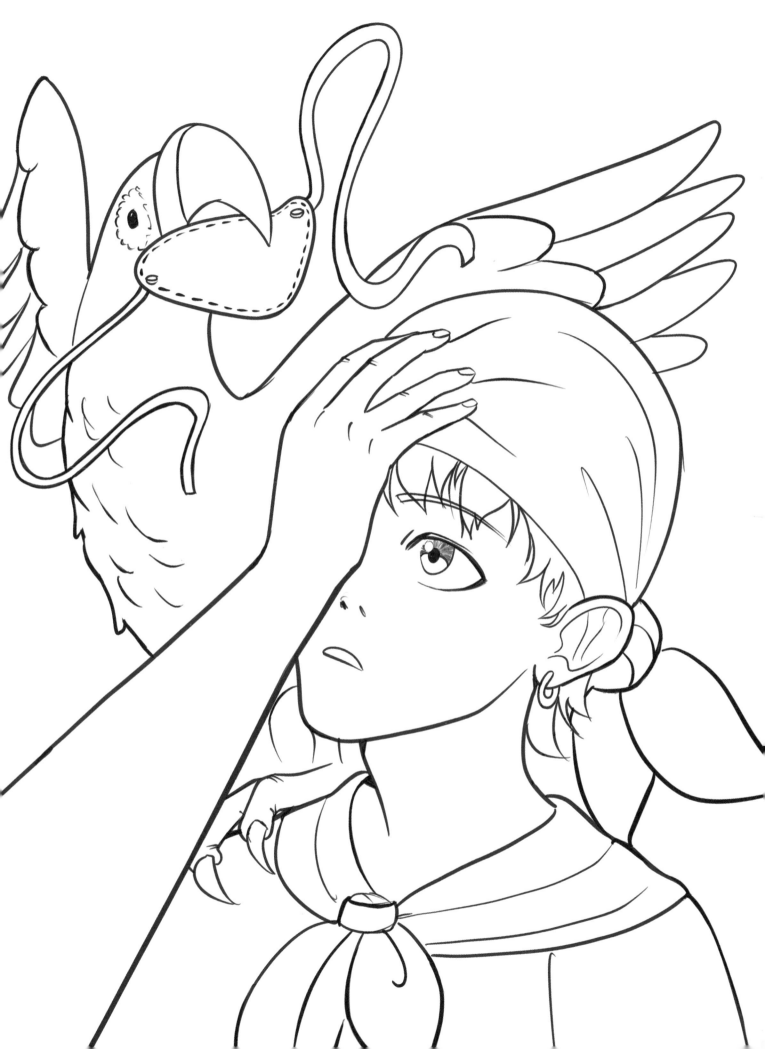

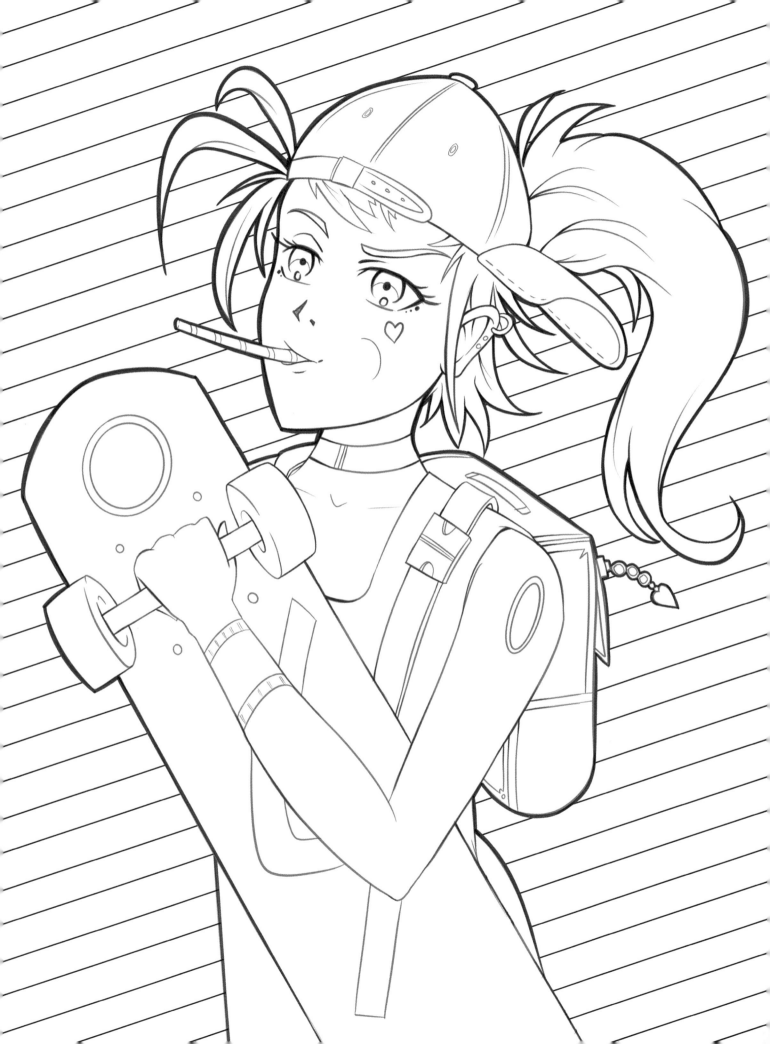

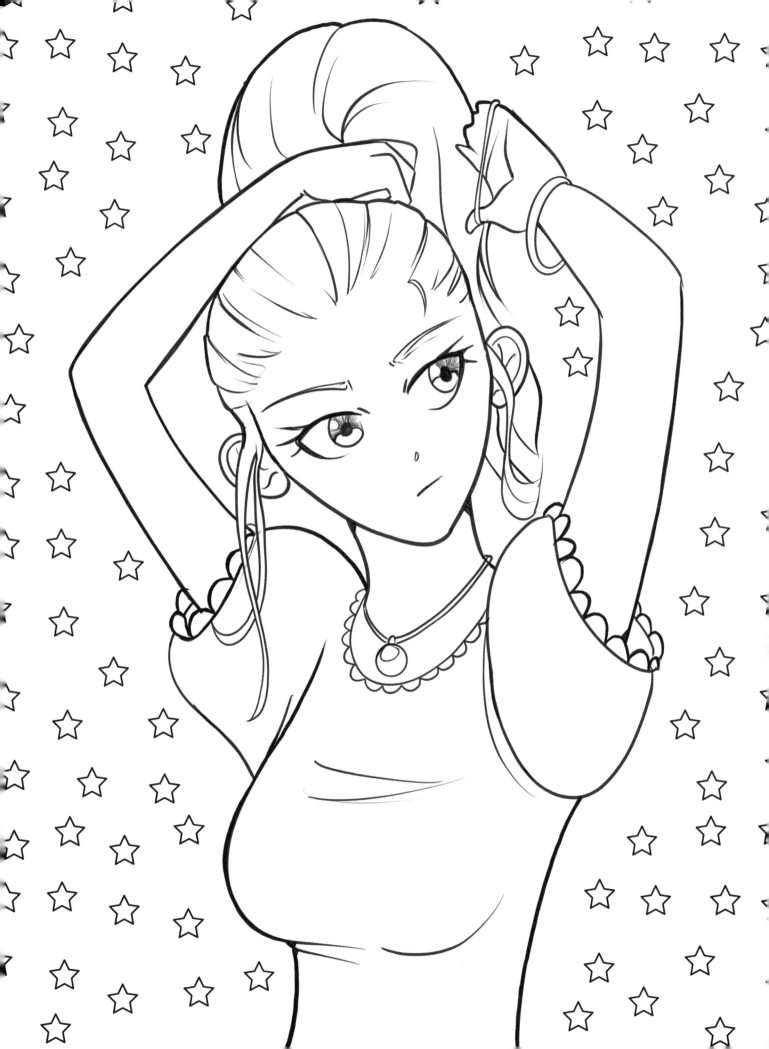

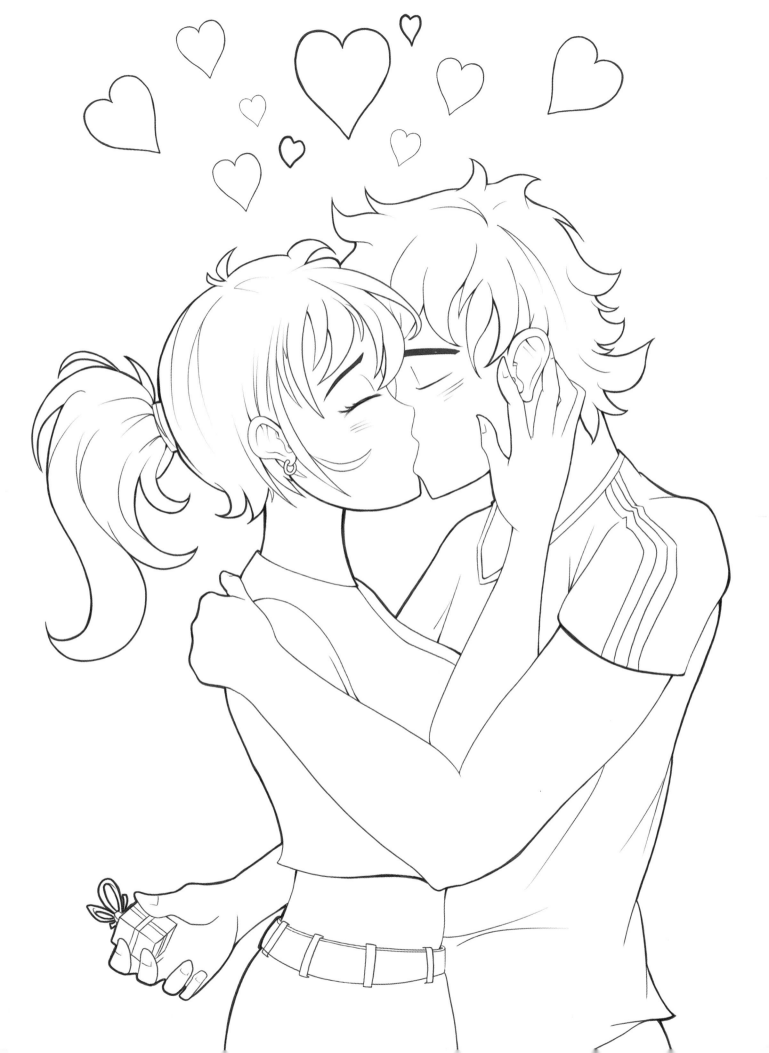

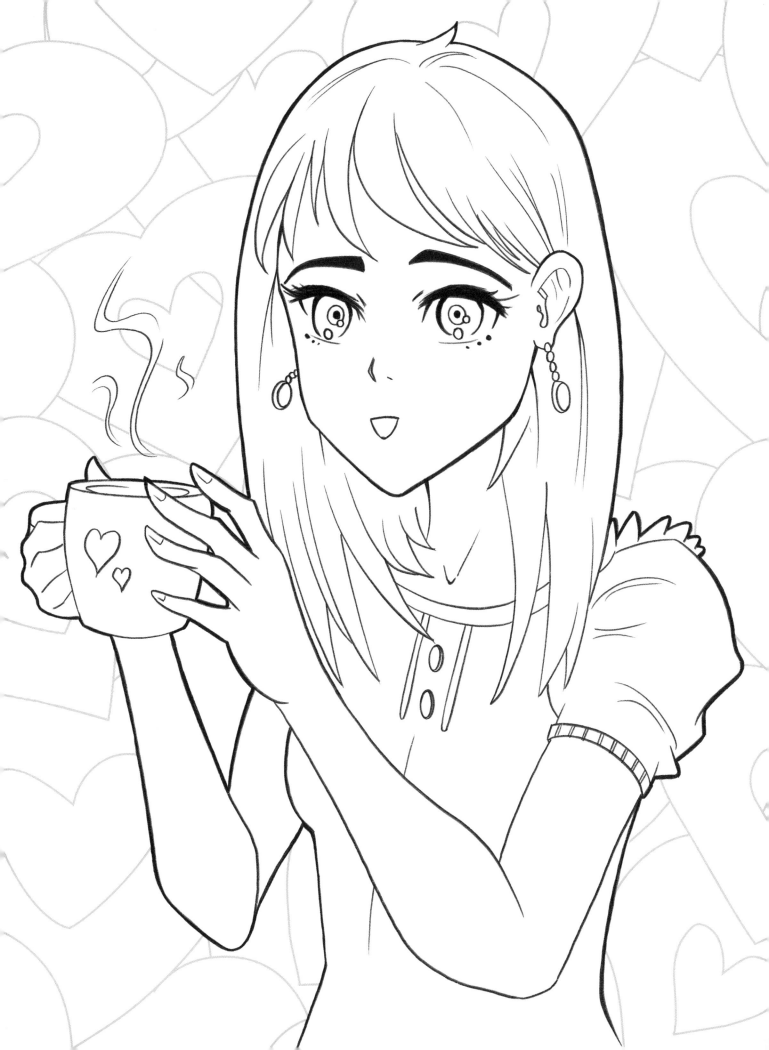

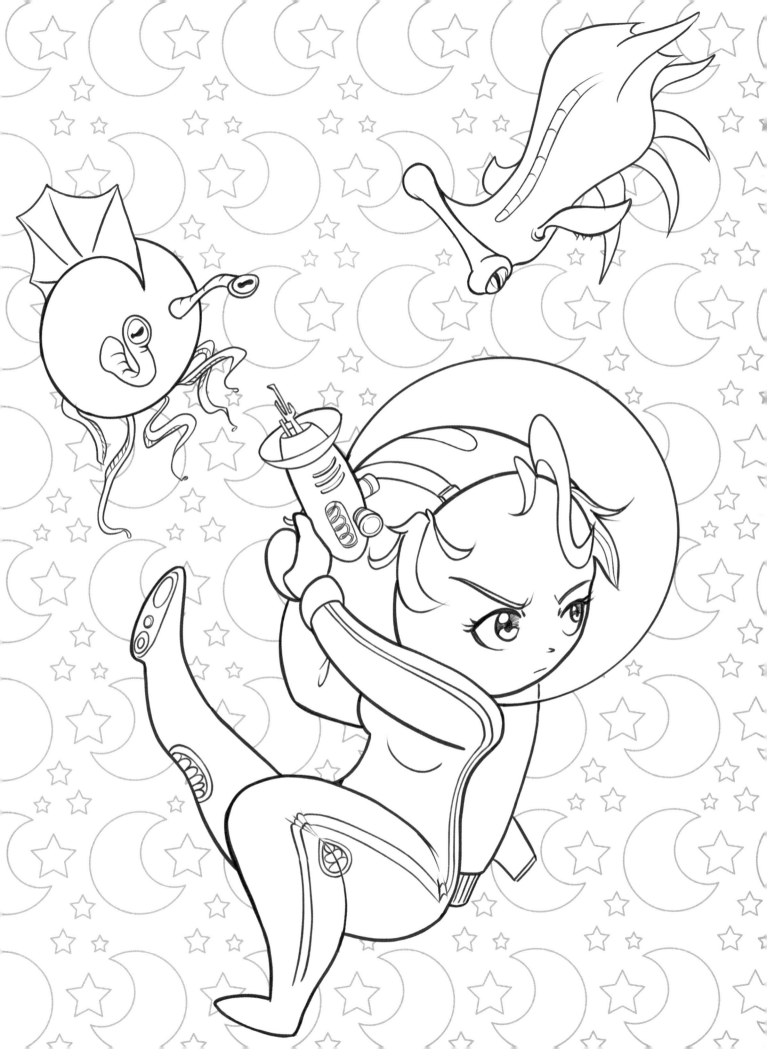

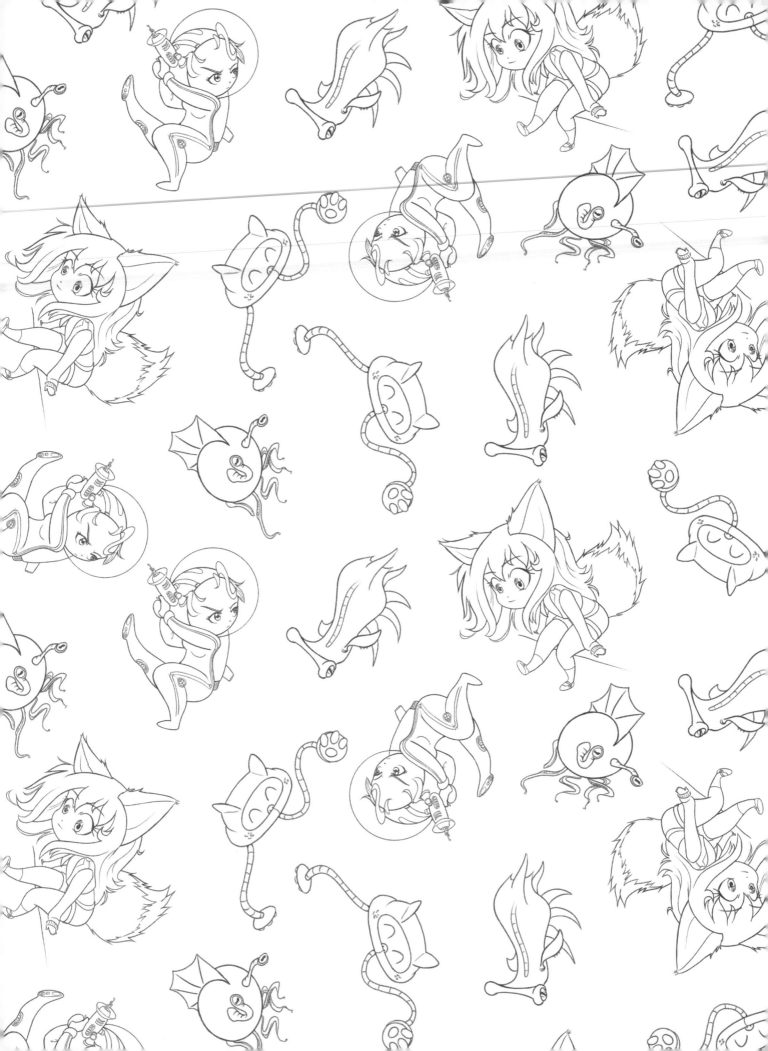

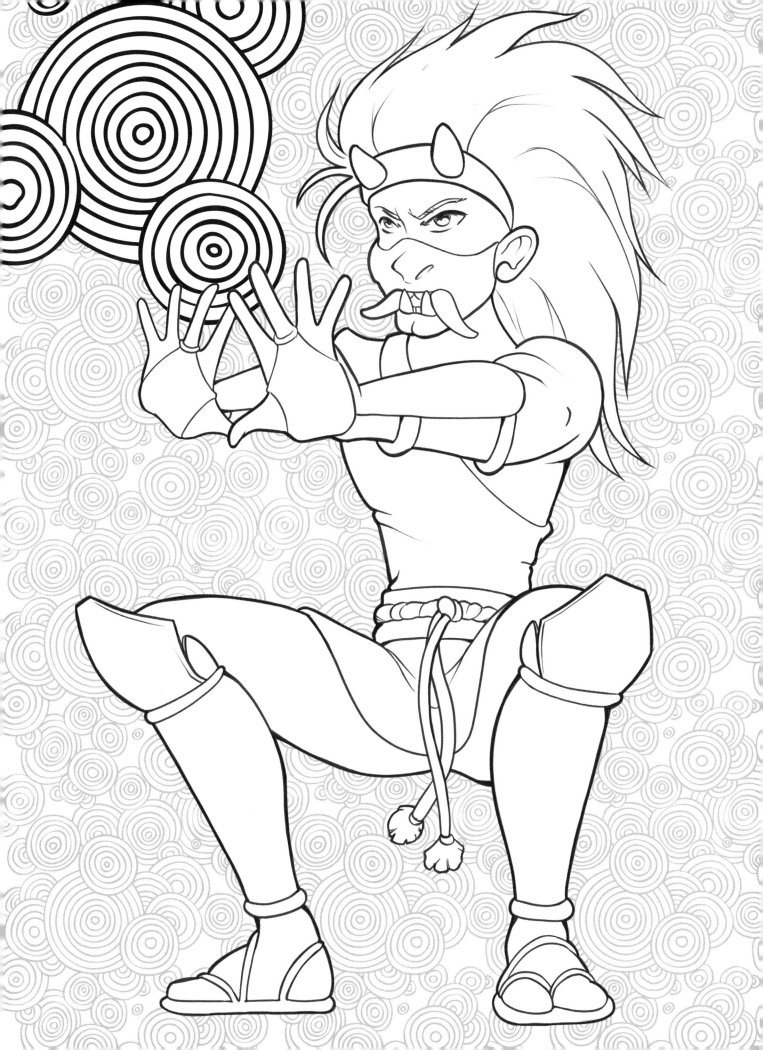

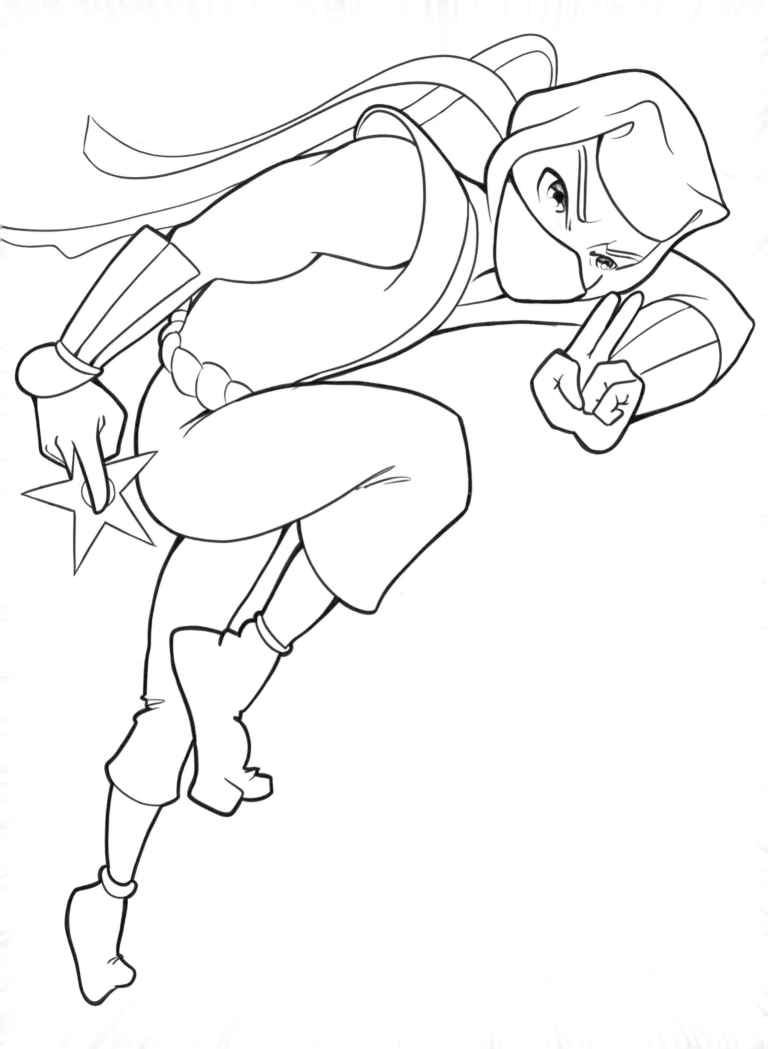

Quarto.com • WalterFoster.com

© 2023 Quarto Publishing Group USA Inc.
Illustrations © 2021 Scott Ronald Harris

First published in 2023 by Walter Foster Publishing, an imprint of The Quarto Group.
100 Cummings Center, Suite 265D, Beverly, MA 01915, USA.
T (978) 282-9590 **F** (978) 283-2742

Contains content from *Draw Manga Style* (Quarry Books, 2021).

Walter Foster Publishing titles are also available at discount for retail, wholesale, promotional, and bulk purchase. For details, contact the Special Sales Manager by email at specialsales@quarto.com or by mail at The Quarto Group, Attn: Special Sales Manager, 100 Cummings Center, Suite 265D, Beverly, MA 01915, USA.

ISBN: 978-0-7603-8493-0

Printed in the United States
10 9 8 7 6 5 4 3 2